FRONT COVER: Leg, 25 × 5½", early 20th century, tree branch with sculpted foot.

BACK COVER: "Sunburst," 99 × 92", circa 1825, photograph courtesy of "All of Us Americans" Folk Art, Bethesda, Maryland.

Unexpected Eloquence

The Art in American Folk Art

by Howard Rose

RAYMOND SAROFF, PUBLISHER
in association with
The Edith C. Blum Art Institute
Bard College, Annandale-on-Hudson

In Memory:
James Kronen
Edith Gregor Halpert
Charles Alan

Published by Raymond Saroff, Publisher, Box 269, Acorn Hill Road, Olive Bridge, New York 12461, in association with The Edith C. Blum Art Institute, Bard College, Annandale-on-Hudson, New York. Designed by Bruce R. McPherson. Typeset by Delmas Typography. Printed and bound by McNaughton & Gunn, Lithographers. The paper used in this publication meets the minimum requirements of American National Standard for Information Sciences—Permanence of Paper for Printed Library Materials, ANSI Z39.48-1984.

First Edition
1 3 5 7 9 10 8 6 4 2 1990 1991 1992 1993

ISBN 1-878352-00-8 hardcover
ISBN 1-878352-02-4 trade paperback

Library of Congress Card Number: 89-064123

Distributed by McPherson & Company, Post Office Box 1126, Kingston, New York 12401.

Contents

Preface

There is, currently, a strong interest in revising the approaches to the study and appreciation of American folk art. This interest is based on need. We have not had adequate criticism of the art created by people hidden away in the far reaches of this vast country—sculptors, painters, quilt-makers—individuals unlike any others. Back in 1979 Howard Rose felt it was necessary (as a writer, collector, and dealer of this work) to make a statement in its defense and to reverse the prevalent attitude of condescension. He set out to find a legitimate place for it in the history of American art, and completed the text of this book in 1982. The first chapter was published in *Art in America* in January of that year. It is only now perceived to be timely, for it establishes the art it describes as a valid art, with standards of excellence as high as those of the fine arts. Howard Rose had been trained as a painter, and wrote with a poet's sensitivity about an art which he identified with and loved.

Howard was born in 1922 in Chicago, Illinois, and died in 1987 in Olive Bridge, New York. He studied painting and art history for four years at The Art Institute of Chicago after serving in the Army in World War II. He moved to New York City in 1950; there his creative outlet changed and he started to write fiction. His first novel, *Twelve Ravens,* was published by Macmillan in 1969. He went on to write five additional novels.

In New York City his background and talents led him to a career in the art galleries. He worked with Charles Alan (Alan Gallery), Edith Gregor Halpert (Downtown Gallery), and the Wunderlich family (Kennedy Gallery) over a period of twenty years. At the Kennedy Gallery he set up and ran, together with Maria Naylor, a separate gallery exclusively for American folk art.

Howard and I began to collect art together in the late 1950's when the contemporary art world was an exciting place. Howard's close friend in Chicago had been the painter George Cohen, whose work he admired and bought. When we first saw Claes Oldenburg's work in New York in 1959, we felt there was a connection to Cohen

(beyond their sharing Chicago as hometown), and became Old-enburg's earliest collectors. That collection of Oldenburg is now at the Pompidou Centre in Paris. The other artist whose work we bought in depth in this period, 1957–60, was Bruce Conner, and in retrospect the early works of both Oldenburg and Conner relate somehow, in the individuality of their styles, to the subsequent development of our interest in folk art. In the '60s that interest was gradually enhanced by finding New York City folk art dealers, such as Kelter-Malce, who were discovering wonderful things all over the country. Over a period of twenty-five years our collection came to include more than 300 items. The variety was enormous—sculptures and paintings, of course, but also furniture, rugs, quilts, drawings, toys, theorems, tramp art, etc.—most of it from the 19th and early 20th centuries.

In the early 1970s James Kronen, a dealer in 20th century folk sculpture, opened shop on Second Avenue. His discerning eye had sought out the works of contemporary folk artists living in urban centers as well as those living in the countryside. This urban folk art in particular was different and unexpected. Jim was a great enthusiast of this work and he made us look and think, and adjust our percep-tions. He may well have been the stimulus necessary for Howard Rose to undertake this book.

A few words now about this publication. The first chapter was abridged and published in 1982 under Howard's direction, as noted above, and appears here in essentially the same form, with most of the accompanying photographs. The remainder of the text has been edited and arranged for clarity. Although somewhat unusual for a book about art, it is not altogether surprising that a novelist should employ fic-tional re-creations to butress his argument, as occurs in the chapter on Mary Ann Willson. Finally, the Appendix is a chapter devoted to problems in folk art criticism; readers might note that Howard Rose admired William Blake, and that his adversarial position is reminiscent of Blake's "Annotations to Sir Joshua Reynolds' 'Discourses'."

This edition has been published to coincide with an exhibition of selections from the Howard Rose / Raymond Saroff Collection of American Folk Art at the Edith C. Blum Art Institute, Bard College, Annandale-on-Hudson, New York, from December 3, 1989 to March 23, 1990. I wish to express thanks and grateful appreciation for help

PREFACE

given to me by Bruce McPherson, Linda Weintraub, Marci Acita, and Aarne Anton. The photographs of the collection reproduced are by Frank Maresca and Alex McLean.

<div style="text-align: right">

—Raymond Saroff
Olive Bridge, NY
November, 1989

</div>

Introduction

American folk art: just what is the nature of our variant
on embellished handicrafts, trifles once produced in cheerful
quantities the world over, that we should explore it for a com-
plexity and ambition which Western cultures have always re-
served to the sphere of mainstream art? Discriminating viewers,
in other ways respectable, pondering a bit of faded embroidery,
or an awkward, crabbed little carving of poor-grade wood, or a
childish watercolor without flair or charm—*pondering* these.
The taste for such odds and ends must be unique in American
aesthetic circles and there is a price of scorn to pay for it, some-
thing of the kind directed at neo-conservatives by their erstwhile
colleagues to the left. The climacteric, exhaustion of nerve, a
retreat to the walled garden—. Nor is self-directed scorn uncom-
mon; a recurrent pang of mistrust in discriminating eyes bears
witness to the ordeal of getting on terms, and keeping there,
item by item, with this most unsettling of republican break-
throughs.

There is no official doctrine to help one (guidelines
within the field are for the most part solemnized predilections—
nostalgia for the cozier life, say). The challenge has yet to be
taken up by the academies which tell us what art is, how to look
for it, when it is present and when it is not. But to date this
service has not been rendered. A little impromptu sport with
some random artifacts, almost always easy marks at the fringe
of the problem, begins to seem less an unfavorable judgment
than that collusion of neglect which has smothered so much
problematic work outside the mainstream.

True, the body of our significant folk art is small, and for
reasons argued below is unclassified as a body. It lacks a coher-

ent norm for its peculiarities, which is to say it lacks its own unique and demonstrated canon of excellence. In no other area of comparable noise on the art market is the viewer left in such ignorance of informing standards: not what is missing in the way of variety and emotional depth, not where it comes short of manual dexterities in other fields (which for many is its un-spoiled attraction), but what it single-mindedly proposes to do, and having done it, stops; structure achieved, integrity found, the rest for proficients. It is the breakthrough to a private sanity in people, largely ungifted, who have experienced metaphysical loss in the realms of order and hierarchy, a proud American impasse otherwise known as freedom, and otherwise (no doubt) a functional gain. When exemplary, therefore, when desperately in earnest, the work can and should be measured by the rule of pure aesthetics, that oldest science of sanity whose law under-pins all fashions of time and place; nothing less will do it justice. Yet one rarely is offered more than a handful of the real goods in museum exhibits, and these so crowded by pop Americana— not even a distant relation—as to blunt the courage necessary to put aside traditional norms. Received wisdom is an obstacle here. They demand the most effacing study, from scratch to the extent this is possible. Like their makers they can be elusive, timid about their accomplishment, with some of the more ambi-tious strategies coded into the least prepossessing genres. No seminary exercise was too mean for patches of first-rate inven-tion. There are difficulties then (girls? fancywork? should one trust it?) but they are not insuperable.

One learns to work along with the seminarians and their frequently ham-fisted cousins. Their discoveries were not for the viewers available to them and in consequence are seldom pointed or "brought up" in the manner of audience-oriented wares. As with most artists wanting a public, a certain short-hand and impactedness, an indifference to the charms of presen-tation (since who is to be charmed but themselves) can prejudice

even findings which are dwelt on and "brought up" (a fluke? should one trust it?). Consistency of approach or surface—style of hand—was never much of a worry to these backwater adventurers. They were after deeper principles of coherence, sometimes flushing light midway through an effort and in their impatience losing all ocular *comme il faut,* what little of it was at their disposal.—But how on earth does one manage to read the stuff? Perhaps one doesn't, in the delimiting sense of bringers and passive takers. A critic has speculated, apropos Duchamp, that art is "an entirely mysterious way" of communion rather than communication.[1] Another has said, of a California light-man, that his art is less before the eyes than behind them, neatly if glibly defining conceptualism, and unintendedly the haunt of the American folk artist.[2] Oneself contributes magnitude, fills out ellipses, adds professional suavities in the head (if one must have suavity) —trust the evidence as it unfolds, works along; just the private art is given, self-referent, impacted and often unlovely, but it can be formal art of astonishing boldness and sophistication and it can ruin your sleep.

The academies don't see it that way, in fact won't see it at all. To be sure, the implications of an isolated aesthetic development in common people, here and there leading to discoveries (or rediscoveries, in the oblivious context of most 19th and early 20th-century American art) of major problems and their solutions, must be an alarming thing to contemplate. Difficulties for the rest of us, which may be challenged or ignored, are compounded to something like a frontal assault on experts in the culture line. Five or six hundred years of unquestioned dogma—: for what is art if not a matter of special giftedness and training, special borrowed or hand-me-down lore, special explicators, a

[1]Henry Martin in the preface to *Why Duchamp,* Baruchello and Martin (McPherson, 1985).

[2]Robert Hughes of James Turrell, who is presently at work on a volcano.

small specially prepared audience—caste, in a word? their caste? Besides they are busy institutions with only so much eye-power and little of it to spare for nonsense *behind* the eyes (communion is not an accredited discipline). The mainstream has become a torrent, there isn't leisure for backwaters at the edge with some yeasty residue filming and obscuring them. Art has never shown this unconcern for an idolatrous public. Behold the main-stream—hundreds of thousands of flaunting visibilities, each borrowed device a gift from God. Look, despair, you ungifted.

And so, nurtured on awe, the casual viewer grows rest-less at mysterious waves behind the eyes from some rude whit-tling of buckled wood, or a workaday quilt without rhyme or sense in its dislocations, tracked with false starts and changes of terms, when around and between are polished specimens of Americana, foursquare Sunday beauties one has come prepared to enjoy with the heart (as per directions within the field). As always one moves along.

Perhaps if a sampling of the real goods were pushed close up in a kind of interdisciplinary mare's nest, only the chaste element and irrespective of period and type—watercolors, glazed wares, fabrics of all sizes and techniques, sculptures band-sawed and in the round, "environments," tinsels, bits of shaped or in-cised bone, chip-carved boxes, valentines, eccentric furniture, towers, pillows—and oh, yes, grand portraits in oils—for the impulse behind this work is in a sense pre-genre, the various modes a result of circumstance or discretion: what tools are in reach, what one quite dares, pressures of local taste and custom, the rest of it: but as with leaves of grass the *impulse* is major and will get through, and a little band-sawed cock is as architectural as a tower—perhaps then viewers would find the key for them-selves. Undistracted by sentiment and gush they might first of all see that here are difficulties to contend with, and whether or not they go on to engage these—the adventure is by no means for everyone—the mere acknowledging it would deliver them.

INTRODUCTION

They would turn wary, respectful but tense, as becomes a viewer of serious artwork. They would begin to grant a certain benefit of the doubt. And they might begin to recognize, after a heedful look around, that this jumble of oddments do pertain uncannily to each other, sheer through the categories and over an interval of a dozen and a half generations, but to little else in their viewing experience. They are possibly symptoms of an ongoing ferment in the American psyche, a still unfinished thrust of democratic consciousness one has not wanted to know about, since it is a trouble to our old world credenda. A "school" of artists without vocation, traditions, lore, mastery of the tools and genres, regional or generational modification, even knowledge of the others' existence? yet affectively a school and profoundly artists, toiling at bedrock structures out in some harsh morning that never abates its rigors, keeping minds active and fingers numb? There is no permission for it in the evolution of societies and categories, their progressive refinement, specialization, noon and decay. We have no precedent for a feral art —.

The viewer is unlikely to drift so far abroad, and is as unlikely to have occasion for it in the near future. The concept of a "school" grounded in roughly equivalent aesthetic ends, regardless of period or choice of form, runs smack up against the genre concept, an outworn fallacy of the mainstream adopted by our very own academics. According to this educational notion there is some expressive or formal identity inherent in subject matter, together with a scale of inherent value in the medium (and of course the size and period and ... but the ramifications are endless), so that portraits in oil exemplify and gloss each other, and ditto historicals, narratives, marines, landscapes, scenes of domestic living, still lifes, on down the rungs to these subjects depicted in watercolor, pen and ink, pencil, cut paper, fabric, etc., and bottoming out with subjects and materials (and sizes and ...) beneath contempt. Now, small harm results from theme presentations when the business is 17th century Dutch

interiors or landscape studies; there is plenty of the real goods, established as such, to tide one over the archaeological filler that currently greys museum walls. It is not how things stand with American folk art. Accomplishment here is sporadic, one might say in a ratio of gold nuggets to pebbles on a stream bed, especially in the major categories where hordes of nervy idlers swell the product, and the authentic impulse, lacking foundations for major or audience-directed work, tends to run thin pretty fast. Out of hundreds there may be a few dozen worth the time of day—but then worth every minute of it. As much to the point, those dozens are by no means established as integers to a distinctive body of work, with its own distinctive canon of excellence. The inevitable upshot is show after show of botched or hack portraits denaturing one that is through-worked and achieved, or a hundred and fifty dead wooden ducks burying alive three or four numinous little sculptures. Not alone do they look terrible among mediocrities, or quaint at best, like our Indians at an English levee, but, insult of insults, *they* look like the filler. The public is not wholly to blame for passing them by, when so clearly the standard is the message.

What can be done? Not much in the present conservatism of the field—a field, it should be observed, as radical in implication as any of the historical avant gardes. Only here the ferment is perennial, not enshrined with originators it could not outlive. For just as there was no archaic age, so there has been no classical age or decadence; sophistication (of the formalist kind) was on hand from the start, and except for numbers of really inspired examples, which seem on the wane, there has been little falling off in that peculiar yearning inventiveness.[3]

But no, the prospects for justice to our native art are

[3]As a curious sidelight, we seem to have lost our remarkable girls and boys of the first half of the 19th century, their places now filled by remarkable 80-and 90-year-olds.

dim. There is, however, one thing you can do on your own: look out of context. Discover for yourself that one grand portrait or those three or four magical ducks—the charge is unmistakable—and blot out the rest. Above all begin to think. Question each of your assumptions concerning the experience of a work of art. Question what that art, the irreducible *art* of that art, what its operative genius may be, which can inhere undiminished in awkward and sometimes trivial forms. Question the word of authorities who presume to settle for you what is major and what is minor. Or, most critically, what is not deserving of serious notice. Meanwhile, look for the charged artifact in whatever guise and don't be soured by the company, whether on the walls or on the hoof. Blot them out. In that one-to-one communion you will be refreshed to your very bones.

(1986)

1 My American Folk Art

By consensus of authorities in the field, American folk art became a "field" in the disjointed years following World War I and the October Revolution, about a decade after the 1913 Armory Show and its esthetic maelstrom, when certain artists of a quiet though respectable fashion took to culling queer old paintings, whittlings and decorated household objects from among castoffs in the junk yards, hanging or standing them together in the parlor, inviting people over for lunch and saying, look, there's a field. Simple as that, because artists are listened to. Youngish dealers listen, rich ambitious collectors listen, researchers without a project listen. It is no matter to them that artists are self-serving and their enthusiasm—or lack of it—customarily has the function of preparing a climate of opinion for their own work of the moment. It goes with the basic gifts of a professional artist, to be able to influence the surrounding weather. Such as Nadelman, Kuniyoshi and Demuth said to look, so a few people gaped hard at the cloddish old junk and presently sensed its importance for them all. They caught the good odor of beginnings, of native sweetness and innocent formalism and untapped reserves; but perhaps most exciting to them, they sniffed a refuge.

Well, they were anxious, that small group of sophisticated Americans in the 1920s. For all their championing of the new, they somehow didn't belong to it, weren't gifted enough or by temperament cerebral or unhappy enough to keep pace with the disaffections from across the water. (Marinetti, though holy, had been a nut, and now ready-mades, and white-on-whites, and Cubist paragraphs, and serial "melodies"—and that Kurt Schwitters!) At which point they were offered the sunny realms

of our American folk. Nothing, despite the vertiginous unfash-ionableness of it all, could have looked more promising to anx-ious sophisticates. Here was a mode of discourse as exotic as the African and Oceanic masks so prized by foreign trend-setters—creations ugly as the day was long, apparently pedigreed Ameri-can, stylized without *meaning*.

Meaning was something that was not in the American grain. One did not agonize over a decorative mourning picture the way one did with a urinal on the rug or a piece of Italian or German despair. No, here was the chin-up art of our own for-ward-looking democrat, at peace with conditions and with him-self. Here was the inventive but modest nobody with a lesson for worldlings: Sincerity. Lucidity. Chastity. Usefulness. Unself-consciousness (with style however). Charm. Reverence, both for his materials and the New World which was his subject (never mind if it seldom looked like reverence or like his subject). Amid the small mementoes of such a birthright one felt the throb known to countless forefront Americans retired from the wars, that germinating of republican values as dreamed by the Founding Fathers (notoriously unselfconscious, modest, chaste and peaceable as they were).

Thus, half a century ago, was inaugurated the sideshow of American folk art; and that it remains a sideshow, at best a bland refuge from significant works of the mind, a place for esthetic collapse and a little parochial flag-waving is the occasion and grievance of this essay. Because what those 1920s sophisti-cates had tapped was the soul not of republican values but of the American genius that could never be at rest with such values.

Serious art, and the kind under consideration was made in mortal earnest, is always backward-looking: the looniest clique (if serious) means only to reclaim ancestral ground which in its view has been neglected or let out to commoners. Don't be flummoxed by radical innovation, that fresh cheese in an old trap. When all is done the radicals want everything as it was:

themselves, you, the distance between themselves and you—
everything. No, the obsessions of art are a great force for conser-
vatism in the world, for radical *equilibrium*.

Forget then the nursery tale of the chin-up, forward-look-
ing democrat with a proud wish for Americana in his home or
shop, who quite innocently produced, or was able to commission
from another chin-up forward-looking democrat, a number of
labored visual bombs that to this day explode in the head with
their passion for something lost. What produced the heights of
American folk art was the attempted dereliction of a culture—of
that feeble yet previously adequate European colonial amal-
gam—with all the old supports of individual integrity to be built
over again, each new nobody as he might; and with no one to
lend guidance at such unprocessed levels (though in matters of
finish and refinement there were poor émigrés around and will-
ing; and with no one to understand what the other was really
doing or struggling to do; and, most anguishing, with no Father
to discourage the effort, to say it was unfair to ask so much of
the unschooled refuse of Civilization. Quite the opposite: some
Fathers appeared to say such effort was vitally patriotic. But
these Fathers enjoined what they had no idea would be taken
literally, since they were addressing not outback folks but the
trained professional castes who would know how to understand
them. Traditions were banished, said the Fathers, history had
vacated the premises—by which they only meant to urge a little
red-white-and-blue in a not-too-new decor. And what the out-
backers heard was a call to start from scratch.

Well, nonsense, you growl. Outbackers knew and cared
nothing about traditions and history, or about the rest of the
contemporaneous world either, except as markets for their
cheese and salt-fish. Yes, but knew and cared nothing, I insist,
as long as these remained a *presence,* some dimly envisioned
standard joining their clodness to the Large Design and assur-
ing them a stake in the best of things at whatever distance. This

much—this vague standard—intact, they could dispense with the knowing and caring about history. Just as long as there was transcendence somewhere, inconceivable grandeurs officially tended for them as they tended the soil and exported the cheese, scarcely anything could set them to nodding faster than small talk of the world and its experience, unless it was having to whack out a toy for Baby, or botch it a coverlet.

But once disturb that presence, impair the reliance on its continued effectiveness here, and folks had trouble getting to sleep at all, uneasy with the passage of years and nothing to show for it. "I reckon everybody wants to leave somethin' behind that'll last after they're dead and gone. It don't look like it's worthwhile to live unless you can do that," said Aunt Jane of Kentucky along towards 1900, seeming by that time to have forgotten what children are for, or what modesty is, or that her products were intended to be absorbed by the community which nurtured them, in prescribed nobody-fashion the world around.

Her forerunners were not so debauched. They were on the whole a narrow, mulish people with much faith in the Fathers and not much knowledge of cultural imperatives. If the Fathers were reported as saying that the old forms had collapsed at the revolution along with George III, primogeniture and the tea excise, there would be something to the claim; likely it had been put to a vote, and everyone revered the vote. Nor would it really matter that they didn't see a breakdown themselves. Home was no less whacked out, botched up and cozily bare than it had been, and the women had quite as many thumbs for their needlework and quite as little ambition. Beauty seemed as always.

No, the point is not that they necessarily believed the Fathers but that they appear to have been ready to stretch those cramped, torpid, European minds. And it was not pride or increased leisure and contentment, but the subtle disgrace of what

is at the heart of contentment, transcendent forms—a loss of the old psychic division of labor—that drove into being the essential American folk art. (Other art too: Bingham's, Melville's—Lincoln—Ives's; but they are sufficiently treasured.) It made us a clod-country of negative capabilities, where natural gifts (scarce) and limits (bountiful) became subject to conception. Signification: a wild immodesty to get the whole lost museum in little every time, each minor mode of decoration turned into major expression, each work a lifework in secret—a *private* excellence.

This privateness, internalizing standards for which the public forms were gone, helps account for the baffling effect of surveys of the work, even work of the highest quality. There was no more shared esthetic between the output of serious American folk artists than there was between *Moby Dick* and *Clarel,* or any pre-Dusseldorf Bingham, and what came before, during and after them. They were whole-life gestures whose fierce condensation, a kind of wedged foreshortening of traditional values that can look merely bizarre in the floating world, does not suit with a "field." Nothing at once so gnarled and vital could.

Some pieces are extant for which no companion material has come to light, and it is assumed that other efforts by these hands were obliterated through neglect on the part of the family or else by flaws of craftsmanship or in the composing substances, often extemporized—that, or perhaps the survivors are modern fakes. But there is a further possibility. They were the whole thing, the exiled tradition compacted into one dense, endlessly labored symbol.

I ask you, what has such an enterprise to do with fields and surveys, with adjacent works as total and private in their commitment, with museums and catalogues and a burbling public—with anything, in short, but moments of ice and fire in the tepid continuum, a jolting glimpse of first principles struggling

to be born, prior to canons of taste and faultlessness, and cherish-able (to press into service a rather unfolklike colleague) simply for those moments' sake?

But to redescend into history. Let us visit a remote corner of New Hampshire (say), about the year 1818 (say), where on a horrendous pine settle in an off-plumb house, might brood a plain, zombie-like, frowning girl. She has noted, amid the recent semi-annual news from "out there," that government is no longer supplying membership in the world, that there are nei-ther historical nor conventional props to support and complete her rough particle of existence, nothing but a three-legged settle chopped by her one-armed uncle; and, it has begun to nag at her, the settle requires mats. Not just any mats: the most re-markable she can devise, more remarkable than anything she has yet beheld or than her sewing abilities are perhaps equal to. Yet they must be attempted, because an excellence has fallen (or been voted) from the air, and she must provide her own. And when they are finished she will piece Baby such a quilt, of such unexampled loveliness, as slobber-nosed Baby will never get the opportunity to soil, but which, should Baby last out the winters uncovered and grow to bed-length, might safely adorn the crib. And when that is done she will paint an astounding box for brother's collection of arrowheads and the family's shed teeth, but brother being a lubberly fellow, perhaps it would be wisest to store it in the closet with Baby's quilt and those remarkable mats since it has meanwhile occurred to her that Pa is a hole-burning clod and doesn't deserve her mats—that they are to be important mats.

Now unquestionably cause and effect were neither so instantaneous nor so smoothly operative. The desolation of clods into esthetic self-consciousness had to be a pokey and devious business. Because, concurrently, there *was* a good deal of ease

and satisfaction—and homemade prettifications to celebrate it—
at the ground floor of things. Mark Twain in his account of a
"mansion" on the Mississippi gives some idea of the variety of
amateur decoration being "committed" a little past mid-point
in the century. (Though one doesn't trust his eye or intentions:
"Bracketed over whatnot ... an outrage in water color, done by
the young niece who came on a visit long ago, and died. Pity,
too; she might have repented of this in time." That doesn't
sound strictly reportorial.)

 Such ornamenting, the pastime or produce of rural socie-
ties everywhere, comprises the bulk of American troves that so
offend our high culture establishment: endless quilts and spreads
for endless occasions, marriages, births, sicknesses, even some-
times for frosty nights; endless toys for the endless children;
endless portraits, shop signs, ship figures, weathervanes, wall-
paintings, floor-stencilings, scenic windowshades, fireboards,
sponge-painted or stenciled furniture; endless needle pieces,
theorems on velvet, mythological fantasies on silk, watercolor
illustrations for *Werther,* mourning pictures, hooked rugs,
beaded objects, "perpetrated" in the schools or on the premises,
by the endless sisters and the cousins and the aunts: leavings of
provincial idleness or small-time commerce, and the establish-
ment is mostly right: most of it does need repentance. Compared
with European country decoration of the period, or Mexican or
Japanese—on the level of decoration, since it aimed no higher—
such work as this only a motherland could love.

 At the same time, perhaps in some of these very crafts-
men and amateurs, there existed viral bodies of our unhinging
national ague, that self-reference of standards at every moment
and in all the spheres, evidently held in check at the seminaries
and quilting parties, or with respect to craftsmen by a dearth of
guild quality European goods to force them in on themselves.
Yet the virus did irresistibly infect the remoter areas. The inade-

quacy of normal American existence would not be thrown off, much less filled by the old remedies of harder and harder manual efforts.

What then were an unskilled—not to say highly inept— man, woman, girl and boy to do in rural New Hampshire, among the stones and potatoes, denied the dimly sensed unity of humankind "out there," and their dimly sensed completion in it, their just-sufficient dole of importance and beauty? Why, put a completion together the best they could—appliqué it, carve it, daub it, *signify* the thing, their private idea of what it had been, though they had never had a private idea before in their lives, and for the sustaining and happiness of themselves alone. And in time there was yielded up a pleasure, a delightful soaring and wheeling of the faculties, a taste and a gift for power over one's situation, a growing passion for what was difficult: a concretizing and integrating, a solved and espoused unrooted- ness to make the old universe an outworn place indeed.

This passion to reconstitute unaided a cultural equilib- rium against all the odds of endowment and circumstance, and without preconception, to explore *for oneself* each form to its utmost, indifferent to the judgment and comprehension of peers—this is what distinguishes the strange temper of Ameri- can folk art from that of any other society in the world. One modest instance: I have a quilt top of rather mundane appear- ance, triangles of variously printed cottons, identical in size, pieced tip to tip in transverse bands, and of no endearing skill in the piecemanship. Yet near the center is an abrupt few inches of counterpointed pattern and color, a delicate essay in the play- ing off of unlike elements, giving pattern a color value and vice verse, holding all in a concolorous equal-density statement, which nobody in the neighborhood could reasonably have been expected to notice let alone find the sense in, as a single iterated pattern would have done the job. I submit that such imaged self-communing, multiplied by hundreds and hundreds of exam-

ples, many breathtaking in their arrogance, the regional decorative layouts forced through intellectual paces, the region casually forgotten and the layout unbalanced by the suddenness of a thought—a five- or six- or seven-inch thought, less occasionally a quilt-size thought, a prodigy of ongoing introspection—I submit this is not commonplace among the world's folk produce. I submit that it is not commonplace for artists of *any* rank, except perhaps the greatest of them, to so defy the deeply embedded laws (or trammels) of consistency.

If it is true, as Alice Winchester claims in her introduction to the catalogue of "The Flowering of American Folk Art" (1974), that "most European countries have their own provincial art—informal, naive, non-academic—which is quite comparable to our own"—if it is true, I say, in matters of ambition, arrogance, inwardness, inconsistency, inutility, infacility, deracination, discreteness—then there can be but one conclusion drawn. The individuals who executed that "comparable" art were crypto-Americans—disaffiliates—America being a state of mind after all, and a factor of the European imagination long before the land itself was named and colonized.

Few intellectual pursuits can be as discouraging as the endeavor to begin to think visually without guidance, or without, at any rate, some natural talent of the eye for finding images ready made in the world. Now, our American folk artists had no more poetic feeling for the landscape, which to them meant vigilance and drudgery, or for the pocked and ever present faces of each other, for reasons as obvious, or for the domestic animals they harnessed or ate, than their counterparts anywhere at any period. Unlike those counterparts, however, they also lacked functioning stereotypes—a body of traditional stylistic resources—by the fourth or fifth generation of their removal here. It is one thing to be constitutionally unobservant; it is another to have none of the "givens" or visual small talk, the casual "you knows," say, of a prevalent color symbolism, or simple code-

work indicating mass, or light and shade, or musculature, to speed one towards the large idea which invests all with its originality. And a shortage of "givens," the scaffolding which is granted one, is no slight affair. If one determines to make a sculpture or watercolor, or work up a quilt, one should not, in the context of Western civilized practice, have to be inventing formally by the quarter-inch. In fact one *ought not* to be doing it. One ought to be doing something else, where determination is less at odds with the practice.

The density, unrelievedness of such invention—maximum invention—is always a trial to the observer. It wants some lurking element of charm; does not center itself and as a result wearies the eye; is overall both successful and unsuccessful, as each quarter-inch takes a judgment, and without shame (or perhaps without consciousness that success is the goal, or perhaps without belief that success is a virtue when one is engrossed with the all but undoable); it will not mingle with its neighbors, will not rest decoratively on the wall or bed or on its stand—there is just no using it to effect, unless (as in the vogue for late Jackson Pollock works) one is prepared to endure aliens for effect.

Even the most hell-fire products of early 20th-century Europe have today precisely the charm of minimum challenge, of irreducible formal assumptions that "bleed" through the revolutionary veil to merge with the ages. We recognize and relax with the hallowed "givens," the 40 or 50 or even 60 percent of academic "you knows" filling out the European esthetic, in which time, the whole time of one's life, the gathering and cresting and subsiding back and into, is an element. And we recognize the old career expertise—articulation civilized and thinned according to a production schedule over an assured span of time.

—Time. How luxurious to have it. Gertrude Stein thought a new perception of space was at the heart of the American experience, but it seems to have been as much the new time.

American Standard Time: pastless, presentless, futured. Democracy, Jeffersonian democracy, Emersonian and Whitmanian democracy, was in the FUTURE, when all inherited germs of civic corruption, and all lingering aristocratic modes of philosophy and beauty and religious superstition were to have been leached away, forgotten, as though they had never been.

But what of the all too sinful clods in their tacky present, their pastless, presentless present which was all of living and doing time they had? It did not go down with them. In fact, all conditions of society seem to have recoiled from this personal markdown, this over-reaching of time towards the future. Southerners in their feudal plantations simply walled time out. Others pushed for the West, to the other shore, making land's end a kind of desperate trope for the utmost edge of the vision. In the empty middle of the country some men holed in and begat the unaging cowboy with the blank, gray eyes. Off East in New England the less adventurous clods laboriously distilled their brains into dense, timeless cryptograms to represent them in the consummate years.

The anguish of these humble folk who had been disallowed the only fulfillment they required—the felt weight and ultimate contributory value of anyone's mere existence—persisted well into the 20th century; the vote was never a substitute. The period of the last 50 years or so in fact provides some of our most exemplary figures, mature men of no previous distinction or abilities convulsed into full-blown eloquence—not in order to rise above their stations, but somehow to establish one, to *have been* before it was too late. That so natural and modest a goal should have entailed such prodigies is surely less a measure of the men than of the culture.

There was Simon Rodia, an emigrant in early youth from Rome to Los Angeles, a logger, miner, construction worker, night watchman, tile setter and telephone repairman, who, in 1921 at the age of 42, began, and for 33 years continued to

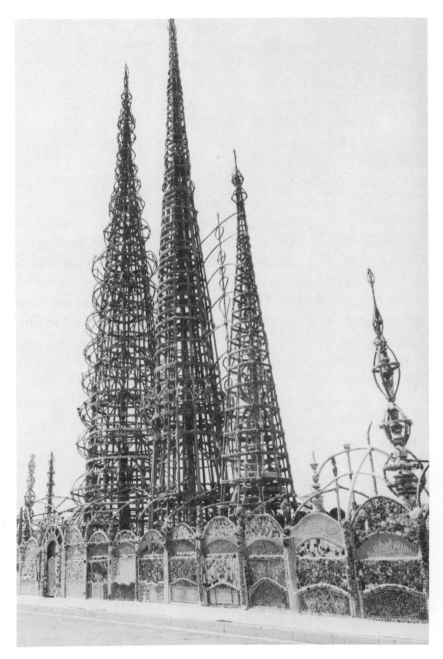

Simon Rodia: Watts Towers. 1921–1954, mixed mediums. City of Los Angeles.

elaborate, a complex of soaring open-work towers which for incomprehensibility and uselessness must be unequaled in the annals of tower building. His materials were, among other things, steel rods and mortar, fragments of bottles and dishes, tiles, shells, buttons. According to *20th Century American Folk Art and Artists* (by Herbert Hemphill Jr. and Julia Weissman), "When he began his towers . . . he welcomed the neighborhood children . . . , but as he grew older, his tolerance diminished, and he began to seclude himself. In 1954, he deeded his lot and his Towers to a neighbor, and disappeared. He was found in Martinez, California, in 1959. . . . Rodia never explained why he left his work of 33 years." Possibly he left it in the embarrassment of having somewhat over-established the small fact and value of Simon Rodia. But he was evasive generally. When pressed to say why he had done it at all, he grossly lied: " . . . because there are nice people in this country." Whatever the truth, these towered bones of an ordinary man, this exoskeleton gorgeous with the junk of Watts in Los Angeles, awesome in its oblivious, labored self-actualizing, quarter-inch by quarter-inch, is one of the sights of the American landscape, almost redeeming the city it adorns.

There was Steve Harley, a failed Michigan farmer who went off to the Pacific Northwest during the 1920s, at the age of 60. When he returned to Michigan early in the next decade, sick and as penniless as when he had left it, he brought with him three preternaturally accomplished paintings of such a density and luster that, as someone wrote after visiting the shack where they were hung, they seemed to irradiate the interior with their own light. No other work by Harley is known. Three *coups de maitre*—of their kind they certainly are—unforetokened, and after which nearly another two decades passed before Harley's death without increment. On the back of one of them he wrote: "Painted by S. W. Harley 'the Invincible.'" Fact and value established—nothing more was required, but nothing less.

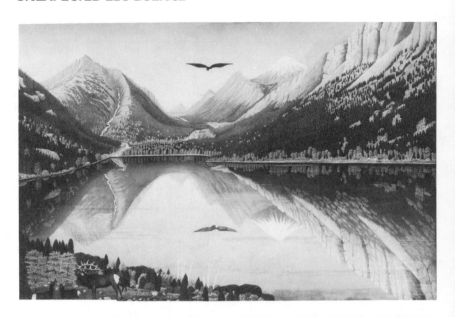

Steve Harley: Wallowa Lake. 1927–28, 24¾ × 36¼", oil on canvas. Abby Aldrich Rockefeller Folk Art Center, Williamsburg.

James Hampton: The Throne of the Third Heaven of the Nations' Millennium General Assembly (detail). Circa 1964, totalling 177 pieces of various sizes, mixed mediums (gold and silver tinfoil over furniture). National Museum of American Art, Washington, D.C.

There was the "thin, timid and bespectacled" James Hampton of South Carolina, who towards the age of 40, while a laborer for the General Services Administration in Washington, commenced the breath-stopping tableau, *Throne of the Third Heaven of the Nation's Millennium General Assembly,* measuring, after some 14 or 15 years of production, 9 by 32 feet at his death in 1964. These altar-like symmetries of discarded furniture, light bulbs, glass jars, cardboard and much similar treasure, all of it completely encased in gold and silver foil, tagged with both coded and exoteric legends, are of a frigid, unreachable beauty that will not let you alone. In the garage where he assembled and stored this marvel was affixed to a bulletin board: "Where there is NO vision, the People Perish."

But perhaps the most remarkable of these ordinary men, because in all other respects the *most* ordinary, was George E. Morgan of Maine.* His biography, as outlined in the *Daily Kennebec Journal* of Feb. 18, 1966, three years before his death at the age of 99, is anesthetizing. The facts are so thoroughly mundane the reporter could do nothing with them. Morgan worked for three months at a furniture factory in Augusta; he worked for Charles Doughty, a maker of harness; he worked at the Commonwealth shoe factory in Gardiner; he worked for R. P. Hazzard, superintendent at Commonwealth, when Hazzard opened up for himself. He performed in the "famous Hazzard band, composed of musicians employed by R. P. Hazzard"— presumably as shoemakers. "He played the bass horn, and, as he recalls, he has blown the horn from the mouth of the Kennebec to Bangor!" He especially remembers playing at the funeral of Horace Cony because, "When asked why he (Cony's son) hired the band, the son replied, 'I want a band to make a noise.'"

[*See the color section for reproductions of Morgan's work.—ed.]

Morgan married twice, produced five children, and at the time of the article had "several" grandchildren. He did not serve in World War I, being too old, but he did get to meet a company captain. "'We sat on a stone wall and talked for a long time,' ... Mr. Morgan recalled." His late years were spent in rest-homes, where he pursued the usual therapies, among them number-painting—*very bad* number-painting—but "sketches on cardboard indicated a talent for more individual expression." By some means or other these came to the notice of Mrs. Wardell, a local dealer in antiques, who began to ply him with canvas-boards and an assortment of brushes. Mrs. Wardell seems to have had one of the great prophetic eyes in dealerdom. A sketch on cardboard exists and though somewhat of an improvement over the number-paintings, it "indicates" nothing like the talent proposed by the Kennebec reporter.

Nevertheless, this same George E. Morgan embarked, at 91, on an oeuvre of about 20 small paintings of which at least a third, in terms of pictorial sophistication, in the strict and total adjustment of design elements, in statement, transformation and inventive interplay of a few simple motifs—an arc, a bloc of parallel dashes, an angled line—recalls the work of the some of the elegant "little masters" of modernism, a Feininger, or an Arthur Dove. Not, mind you, as *painting*. Morgan was no more a painter manqué than (I suspect) he was a harness-maker or furniture-gluer or any of the other employments he turned his hand to in that long casual existence. Even allowing for the incapacitations of 90-odd years, the surfaces are often scrubbed and smudged beyond what is really consistent with painterly talent. No, what he had, or abruptly generated, was a rigorous formal grasp of his work: the imperatives of shallow-depth organization. Morgan not only grasped those imperatives but doggedly explored the possiblities in eight or nine awkward little successes, a feat so evidently exhausting to him that in signing one of them he misspelled his name—and Morgan is not an easy

name to misspell. (If you say, well, he was in his 90s, I say, well, he painted the picture.) And then while his evocations of mill-streams and icehouses and covered bridges, each with its scrawl of identification on the back, would appear to be the routine stuff of much Sunday-painting wistfulness, there is no warmth—nothing but cold intellectual throes, the headlong crystallizing, exoskeletonizing, gold and silver foiling of George E. Morgan, his fact and value in a culture which had neglected to provide such things as a matter of course. It is hard to see another occasion for this strange adventuring of an unadventurous mind.

The nub of it being that, with the possible exception of Steve Harley, these were not gifted men in any traditional sense, and what they were making was not art. not fundamentally. They seem to have been putting together, with less or more advertence, a sort of private history in personal time outside the culture. Of course they weren't the only ones: Eakins did it, Ryder, Bingham, Melville, Dickinson, Poe—but these were classified talents whose business it was. What is significant in our nondescripts is the revelation of a unique—uniquely *common*—American experience. For well over a century it made potential geniuses of us all, enforcing the solitary manufacturer of an American esthetic—a life-esthetic, a sufficient, dignified and somehow integral way of having been in the world of higher consciousness that seemed no longer operative here.

And one giveaway feature was a most unfolk-like cere-bralism, a mindcraft (if not generally craft of the hand) linking up the divergent temperaments. Mary Ann Willson, an outrageous young woman during the first decades of the 19th century, in a log cabin built by herself, achieved a few—well, a very few—ham-fisted watercolors which in underlying formal discoveries are wonderfully close to the efforts of George E. Morgan, a bland old part working 150 years afterwards in a nursing home. Surely if we must search out continuities and traditions in American folk art, and honestly do mean to find what is

American and what is art in it, there, in those apparent *dis*continuances, in expression at once too bold and too private, too ambitious and self-referent and made-from-scratch to take its place in a genial folk tradition, there is where to look.

II

And so it came about in the decades following nationhood that here and there among the indistinguishable gust of artifacts— "childish" work of "modest competence" (as Kenneth Ames would have it) that seldom deviates from (in John I. H. Baur's words) "a certain middle range of expressive power"—oddly expressive "sports" began to appear. Unlike work of the next century these lay invariably within conventional disciplines (such as they were), and even in internal schemata were often so close to other produce of the kind as to escape detection—not mysterious considering the shy women and manly men, or travelling artisans with a living to earn, who were responsible. Or irresponsible: the truth is they were being as subversive of Jeffersonian and Jacksonian ideals as any old monarchist sympathizer and seem to have felt it.

In the main, accordingly, they bored from the inside. Folded on a closet shelf between goodish quilt-tops was one too densely, feverishly beautiful; in among all the carved gay animals was an inscrutable horse the children rarely touched; out of doors swung a home-fashioned weathervane, similar in pattern to three or four others visible on the street, but compelling the eye by virtue of some extra, not to say uncalled-for, presence in it; from the parlor molding hung a portrait, too eccentrically colored and aggressive for the nice little room.

One thinks here of portraits ca. 1815 by the comparative tyro Ammi Phillips—active into the 1860s—which really are too out of the ordinary for comfort, annihilating everything else

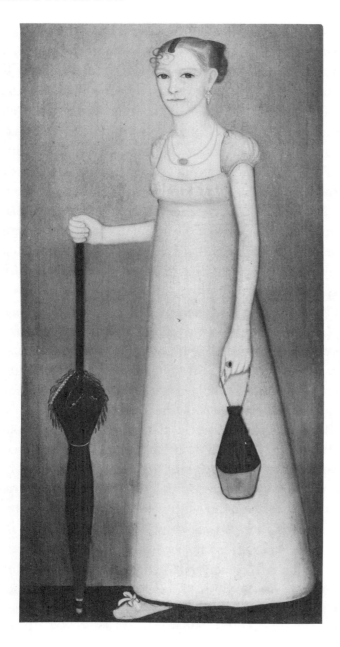

Ammi Phillips: Harriet Leavens. 1815, 57 × 28″, oil on canvas. Fogg Art Museum.

in their vicinities. *Colonel Joseph Dorr* and *Harriet Leavens* all but constitute a genre to themselves, no more harmonious with a tradition of naive painting than defined by its normative limitations. Edge to edge they are totally and consummately *achieved*. In formal coherence, in ripeness, in sensibility shaped and refined stubbornly upon itself, there is nothing to come near them in educated American art of the day—which, excluding Raphaelle Peale, is saying little enough, to be sure—and in the line of portraits perhaps nothing to succeed them, not even in Phillips's later interesting but mannered production, until 30 years subsequent when another journeyman, with much previous hackwork to his name and much that would follow, Erastus Salisbury Field, incredibly contrived the glowing *Miss Margaret Gilmore,* in all respects as ripe and masterly as those two phenomena of his more gifted colleague.

One looks and looks at these "sports" and endeavors to make it out: here is isolated work of near-genius by people without genius. Now it is certain that no amount of intention will raise a third-rate to a first-rate capability, not for a single instant in a long and dedicated career. Inexpressibly sad but it can't be done, the publicists for art in this country notwithstanding. When Barbara Novak first attempted to thin 19th-century American painting down to size, disengaging what seemed to her of genuine worth and resetting it in, or parallel to, a tradition of "Luminism," she ended with something on the order of six to eight names. There is a fierce wholeness of the mind in optimum articulation that may not be had for love or skill.

Accident is equally out of the question: one does not accidentally master and fuse the elements; neither will inspiration do it. An inspired third-rater will bring off inspired, short-winded passagework, for which see West, Stuart, Trumbull, Vanderly, Eichholtz, Jarvis, Sully, Waldo, Harding, Doughty, Durand, Morse, King, Cole, Wyant, Page, Francis, E. Johnson, Whittredge, Church, Cropsey, Rimmer, Bricher, Bierstadt, and

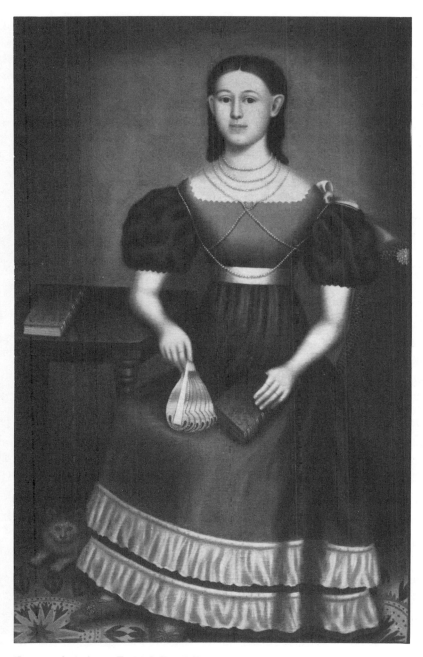

Erastus Salisbury Field: Miss Gilmore (Margaret). 1845, 54 × 34″,
oil on canvas. Museum of Fine Arts, Boston.

on and on. Not a consummate work among them, though all were ambitious men with a degree of talent and now and then some striking ideas.

Yet just this improbable crossing of boundaries, from a barely "modest competence" in "a certain middle range of expressive power" to seemingly arbitrary strokes of near-genius—or *a* stroke—was an eerie latency in so many American provincial artists who have left us a body of work to go by, down to the humblest triflers; for example, an Emily Eastman. This Mrs. Eastman of Loudon, N.H., a rather featherbrained watercolorist of subjects based on fashion prints in the 1820s, once went all out on a Fuselian visage—discreetly bowered in typical Eastman hairdo and laces—that for staring demonic thrust, for exact, meticulous, literal plasticizing of sub-zero desire and for authority and finality on the subject, leaves the master somewhere back with Lancret. Yes, the inarguably "child-like" Mrs. Eastman came up with a single (to my knowledge) climactic stroke, one perfect clench of the mind: capability simply off limits to her educated betters, or to provincials elsewhere.

It is, however, the numbers of anonymous one-of-a-sort pictures—entire small and exclusive worlds, like souvenirs of as many lost continents of the mind—whose peculiar esthetic weight gives character to the "field" of early American folk art and disquiet to its theoreticians (somewhat to stretch the term). Being anxious for respectability, the latter do not greatly like "sports," or, it would be juster to say, do not greatly like to publicize the misfortune of having them as a representative mode. They do greatly like coherent bodies or possible bodies of work with names or possible names to go with them, and biographies or possible biographies to go with the names, and everything to be contextual or as contextual as possible.

Historians (*the* arbiters of respectability nowadays) of course frown on uncontextual creation. They deny such a thing can exist, and if presented with evidence will deny it is evidence;

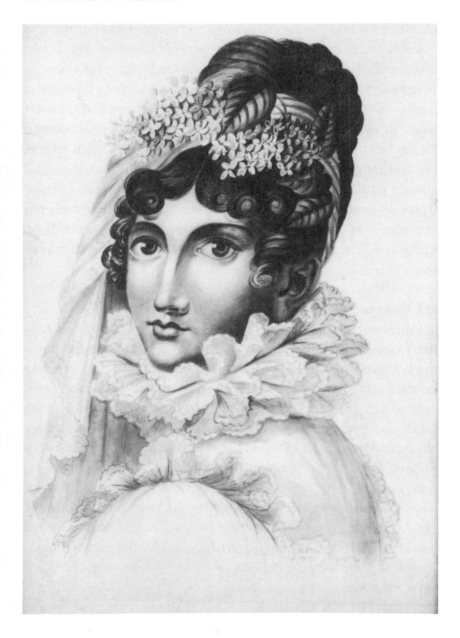

Emily Eastman: Portrait. Circa 1820, 17 × 12″, graphite on paper.

or will say it is not sufficient evidence, or is *ipso facto* but not *ipso jure* evidence; or will suggest you have not seen all the books and are mythologizing. Forced to acknowledge that the essential American folk art does detestably, visually resolve to a jungle of unprecedented "sports," leading nowhere, not even to the next work in an oeuvre (where one exists), altogether unaccounted for in textbooks, the historians will drop it right out of the lecture halls and museums of serious art. Well, and though I am sorry to make trouble for the anxious theoreticians, I repeat it has no business being there. It is not lecture-hall or museum material, it is pure—self-referent—heterodoxy, quarter-inch by quarter-inch and edge to edge, and, as such, resistant to survey methods.

How can you be Ciceronian about something that will not be explained in terms of something else, something nearly identical with it in all but excellence and that strange excellence the whole impalpable point? You can't. Where purity alone is the hallmark, and lineage is not from quilt to quilt or portrait to portrait but from quilt to portrait and crosswise to weathervane, or theorem or embroidery, or whatever next is maximum in its kind—gold and silver foiled thrones—it would be safest after all, considering the lack of university guidelines towards such a project, to retreat to "Luminism" or, for that matter, folk-art-as-refuge.

Yet this anarchy of norms has its deep significance for American studies: quilt with portrait with weathervane; homecraft cerebrated into art; art by nobody, by anybody—oh, now and again by one Phillips or Field, by some James Lombard, by a Harriet Powers, but even here, those pieces of theirs entering the true current are in effect, with regard to *their* norms, as anonymous as any door-stop or hitching-post. So let the theoreticians codify and delimit to appease their longings. The American folk art canon—that relatively small product of uniquely American solutions—remains intractable: disorienting

to make terms with piece to piece; impossible to make terms with any other way; charmless, indefinable, deracinated; all in all an art-historical nightmare.

What then would be its interest for people today with enough that is obscure and adrift in another world without norms? Simply, the uncrutched *weight* of things, the implications for a major new art that might have been, lock, stock and barrel art, to take up and individually structure the void, raise rootlessness to a positive power. Simply, the glimpse of full integrity, which if one cannot finally approach (as one can approach the art of museums), will for this reason never fade or pass into knowledge, but will be a thing forever and therein a joy. Simply, the integrity.

It is, furthermore, visual speculation on a high level, in a few instances as high as the age and country produced, and ranged in their hundreds these crabbed headworks confer a sort of grace on an otherwise debatable social assumption. De Tocqueville appears to have seen all consequences but this. Hundreds of desperate grapplings with primary laws, as if the great ones had not long ago done it for us—as if, a witty theoretician remarks, the wheel had always to be discovered over again. (It does, of course, in any real act of creation. Over and over and over.) Suddenly so many lumpish brains of refinement and inventiveness—declassified *random* invention that wouldn't earn a man a dime or a vote, and in areas where it could not have struck de Tocqueville to search for democratic consequences. In fairness to him the clues were hardly such as to hit a *soigné* Frenchman between the eyes, nor was there the abundance to warrant aphorisms if improbably some of them did. But just a scattering—a handful of clods, louts and oafs, beansnapping girls and vertiginously old men—bungling through to a fusion till then reserved to the supremely qualified: imagine that.

2 Of Weight and Measure

It can be argued that I have devised a gauge for American folk art which is little more than the standard of its preeminent pieces; that by rejecting formula work in the traditional categories I have not so much surveyed a field as invented one after my heart's yearning. Any field, it can be argued, will tend to gain in wondrousness when its broad average is ignored and the exceptions are offered as representative.

In some sort I have done this, if it is invention to point out a body of vital aesthetic work, incoherent except with itself, scattered among the artisan and domestic welter presently being offered around as American folk art. I am not selectively building a case for the average, or type, of our provincial handicrafts, from a few atypical specimens, ignoring only to enhance by indirection. I ignore because the average does not enter into my subject of American folk *art*.

Critical factions seem intent on preserving as an assumed objective quality for research and demonstration a radically heterogeneous mix of look-alikes and similarities. By working within an arbitrary construct of American "folk" art, the schoolmen are able to present their briefs against a genuine native art by inference and innuendo, on rule of the analogue. For example, if such and such a commercial weathervane can be shown to be derivative from Currier and Ives, who in turn may be derivative from old-world prototypes; and if such and such a fraktur is manifestly a corruption of an ages-old German layout; and if such and such a seminary watercolor is parasitic on a well-known English print, down to its lettering; then all American "folk" art, as products of a governing folk ethos, would likely be tainted with unoriginality.

When genuine native art is scarce, and the public for it is growing in numbers and waning in discrimination, one will be tempted to keep the boundaries as fluid as possible. Of course, it dims the peculiar luster of our feral art for it to be seen piecemeal among traditional craft and amateur scourings; yet I think few disinterested people will find that there ever was a coherent American low culture as staked out by the early entrepreneurs and organized by their successors. I think they will find a number of diverse modes of activity whose resemblance to one another in the prevailing view results solely from their non-resemblance, in however diverse ways, to an old-world idea of fine art. On this view, whatever is not conventionally "fine" is "low": naive or folk or cottage or artisan or amateur; differences tending to bleach out in light of the major distinction.[1]

I do recognize that speculation naturally, sometimes helpfully, grounds itself in polarities. However, these must be subject to continual challenge: since they are fixed grooves or tendencies of thought, not to be avoided except through some factitious program with equal dangers, their contents must be redefined and redeployed as the evidence warrants. In their con-

[1] It doesn't say much for the enterprise of our scholars that an unprecedented itch in the American folk to be making something—thousands and thousands of them a while back, and perhaps but once succeeding so long as it was whole—should get tradition-bogged in rough and outworn antitheses. In fact, such pre-Ruskin and -Berenson concepts—fine against "Gothic," high Renaissance against "primitive"—are rather worse than outworn as gauges of value; they never were remotely applicable here. Subsets apart, we were a mongrel race with whom a unified low sensibility, qualifying all the products of a typical low culture, was hardly a force; while the few real achievements of our high culture showed a disregard for canons of taste and urbanity, a crabbed, provincial search for personal forms, for integration at any cost; not at all according to cosmopolitan ideals. Not only was our low culture indeterminate, of many strains and degrees of ability and intention, but at points our high culture reached down a way to make common cause, precisely against complementary spaces of experience that no longer fulfilled each other.

servatism they must not be allowed to choose the evidence for us but we for them; by this means we may compel them (to compel us) to new and more useful discriminations. On the question of high against low in American art, we will be satisfied with less than outright dismissal. Too many experts have made careers of guarding orthodoxy at either end of the spectrum, and over the decades have worked up a kind of chart or wheel of opposites: "serious" and "decorative," "innovative" and "traditional," "original" and "improvisatory," "individual" and "communal," "self-conscious" and "innocent," "intellectual" and "spontaneous," "abstract" and "organic," "conceptual" and "visual," and so forth. The thing is too ingrained in our discourse. We will keep the distinction, only with a little testing of terms and standards, and a slight adjustment of indicators, to see if an old-world formula can be made to yield us some new-world bearings.

The formula's general utility is not under debate. Within the post-Renaissance cultures of western Europe there do seem to have emerged, and progressively diverged, two major strains of aesthetic consciousness, regulating between them all modes of fulfillment: the court or "high" (adventurist, egocentric), and the folk or "low" (conservative, communal). Excepting an unaccountable Douanier, or a visionary Blake, or some indefinitely sophisticated "natural singer" such as the Dorsetman William Barnes,[2] the gifted European tended to conform himself to the practice and tastes of one or the other establishment. The peripherals, that multitude of shadowy crossovers, *naifs* or *provincials,* do not engage the formula. If a man reared in the artisan skills of the low nurture proved to be inexpediently gifted—or,

[2] Of whom Gerard Manley Hopkins exclaims, apropos his having written an English grammar in "an unknown tongue, a sort of modern Anglo Saxon": "But the madness of an almost unknown man trying to do what the three estates of the realm together could never accomplish!" Just so.

only modestly gifted, developed too much self-consciousness—
he veered not towards a unique identity of his own, along princi-
ples of his own discovering, in outer darkness but inner light (it
never was a European option), but towards identity with the
traditional other art; reshaped himself to the degree he could on
the dominant high model and the requirements of its audience;
and it is immaterial that he mixed aspects of both in queer,
piquant work typifying neither. The queerness, whatever now
may seem of peculiar temperament or originality, was in fact
miscarriage. *By intention* he was an academic, and in effect
rightly a failed one, to be judged by standards he did not
achieve.[3] Hold it in mind: serious outsider work was not a possi-
bility. There was no normative middle ground, no criteria, no
audience, and to the professional sense of things (the career) no
fulfillment, than subsisting in high or low, fine or folk. It is the
formula's essence.

Accordingly, in an exposition of high style painting of
such and such a culture during such and such an epoch, one can
expect to discover some ideal or ruling tendency jointing all
units into coherence. It may not be a coherence one can point
at, since much will depend on shared negative values: what was
not done or attempted to be done, what strategies were not
currently in favor as being expressive or beautiful, even though
those in favor were but inconstantly realized. Yet if one looks
long and hard enough through a rough pattern of iteration and
exclusion, a basic discourse will begin to clarify, an ideal of *the
picture* for that age (or that tendency of that age) which should
provide an index for measurement. "Success" will then be seen

[3]The syndrome was in particular evidence here during the 18th century.
There were the junketing Britishers William Williams, John Smibert,
John Wollaston, Joseph Badger (*very* failed) *et al.*, along with a scattering
of more impressive colonials on the order of Ralph Earl and Winthrop
Chandler.

to hinge on the mastery of a certain idiom of paint texture and application, of color dynamics, of conventions of drawing, light, form, mood, iconography, balance of parts in an underlying spacial concept, etc. The consummate thing will be that effort in which some final rage of mind or character welds the highest mastery of separable, measurable skills into an inseparable, immeasurable whole.

Three observations. First, the elements, the separable skills of major work (or work of a major artist), are subject to reckoning, and a falling off in any one of them can cripple the broad thrust, as frequently with Goya or Copley. Major high-style work presupposes major dexterities. Second, all the works in a medium (of a time and place) assess each other to some degree, and quality is measured by gradations of an implicit standard of excellence: who has done, what all were doing, better or best of all. Third, over and above gradations of excellence, there are standards of significance or profundity within the western high style, and an adjustment in our force of application as we move along. This is to say, there is a hierarchy *of* categories as well as within categories; certain of them, as categories, are less or more serious and attentive, galvanizing an altogether different level of responsiveness than the others. (The shifting hierarchy of subject matter does not involve us here.) You may secretly have more pleasure from a remarkable painted fan than you do from some full-length portrait by Nattier, but you will harbor no doubts as to their being worlds apart in significance. At least I hope you won't, since the fan-painter and Nattier would have harbored none, understanding just what stress of ambition a fan would bear and what a gilt-framed stretch of canvas. (Such hierarchies rarely held, I believe, for either work-man or spectator, in the oriental and so-called primitive cultures.)

Accordingly, in a family group of conventional folk art, say, of the Pennsylvania German subset during the first third of

the last century and a while before, one may expect to discover some humble counterpart of these attitudes, only with standards localized and on a different footing, and with of course "genius" and "the consummate thing" no longer a question. We may expect to discover it because structures of taste, though not the judgments, seem to be fairly constant among Western civilized people. In fine and folk cultures alike, mastery of the traditional rudiments of a craft is of overriding importance. With the high art, finesse can occasionally be all there is, and enough to keep some fluffball of a Nattier in the museums. With the low it is virtually always all there is, since the format or schema is rigidly convention-bound; or at the outside, as in the case of Pennsylvania Germans, rigidly symmetrical, allowing to a gifted person no real growth but in the craftsmanship. The best specimens in our hypothetical group of artifacts will be those which are most skillfully done, whether by virtue of finish or decorative complication of received figures.[4] The figures themselves, however—tulips, hearts, crowns, unicorns, swastikas, angels and such—are inviolable, and can be embellished but not made ambiguous or "romantic," just as the symmetrical schema can be varied somewhat but not to the extent of obscuring symmetry—conservatism—the social and religious principle of God's order on earth.

In this sense, folk art, the authentic, traditional form of it (which is not "primitive," a stage of development, but fully developed expression) is not strictly an art at all, at least by post-Renaissance specifications. It is not invention but a modest garnish on what was invented once and for good, what Kenneth Ames [*see Appendix*] dismisses as flourishes beyond necessity; or what John I. H. Baur most have had at the back of his head when he referred to "quality [that] has rarely sunk below or risen above

[4]Ineptness, though prized by a few connoisseurs for its own sake, is not a general criterion, nor can I suppose it was for those Germans who made and used the stuff.

a certain middle range of expressive power." Apart from the craftsmanship, there can be no exorbitant work as there can be no utterly failed work either. All is convention, transcription from exemplary models, and only those with some aptitude and training would have been patronized. But we must look for nothing hidden or echoing, no tensions resolved by intricate formal devices (much less tensions left unresolved), no inexhaustible residue after canons of skill and orthodoxy have been satisfied. Any peculiar deployment (to modern eyes) of iconography or color, and hence of possible original discourse, can be laid to ignorance of symbolic values which long residence away from the heartland would tend to promote. As Frederick S. Weiser sums up in his elegant precis, "Pennsylvania German Folk Art," in *How to Know American Folk Art* (Dutton, 1977), "The artists exercised their muse within the confines of generally accepted limits—limits imposed by the uneducated, unsophisticated, provincial and informal tastes of the folks whose things these were. ... As an art form, belonging to and springing form the community of Pennsylvania Germans, it may be one of the few that genuinely deserves the name *folk art* in American life."

In gist, the foregoing is the bipartite formula, and it has been employed by schoolmen to insinuate that the extraordinary things in our folk art are, *can be,* no more than as yet unresearched parrotings of high art models; and by artifactualists to prove the demonstrated limits of the provincial mind.

I allow that in the old-world configuration for which it was devised the formula makes useful distinctions. The problem is with its usefulness to the myth of American folk art, because if nobody nowadays would think of applying it downright to our native enigma—I like to believe we have come so far—neither do they get around to an alternative theory. It continues to haunt, perplex and at length mediate all arguments on the subject, no matter how bravely and adventurously begun. High

art is played against low art on the precept of categories nobody intends to be using.

Jean Lipman, once as brave and adventurous as one would wish, in a 1946 article for *Antiques,* "Print to Primitive," met head-on the charge of a derivation (not to say theft) of ideas from the high and popular cultures. She did not deny it, she made a virtue of it. She claimed, and documented the claim with illustrations, that in some instances the primitives (as she then called them) were superior as works of art to their originals, and must therefore be appraised as originals in their own right. I imagine the thing is settled by now for all but moralists and academics. So there was a brave beginning—works of *art:* good-bye to the *folk*. But having established the claim she went on primitive "masterpieces." Now, a masterpiece is "a supreme intellectual or artistic achievement" (Webster, Abridged). "Works of art" should have been achievement enough for her purposes.

More troubling, however, is the power play for what is traditionally a high art value. The effort is surely irrelevant to a novel type of aesthetic activity whose imperfections—*un*mastery—have to be central to any scrupulous definition. On the other hand, it is surely relevant to the formula, which Mrs. Lipman appears rather to be conciliating, by working for status *within* the scheme, settling for a kind of mirrored or micro-importance, than to be fundamentally challenging. She deepens this suspicion by whetting some points:

> "In a recently published article I discussed the basic 'points' by which masterpiece primitives may be recognized. All these points have a common denominator which might be described, in its most general terms, as fine stylized design. This depends on the uniform clarity and quality of balanced design created in terms of sharp simple forms and bold distinct line, color and tone. Subject matter and verisimilitude are definitely secondary—exactly reversing the emphasis of the typically academic painting or print."

In effect what we have here—and it has been an influential set of points—is a restatement of the measurable characteristics of folk art anywhere (not to mention child and "disturbed" art—the singular Martin Ramirez, for instance). The formula affirmed, only with large asseverations for the craftsman knack of reducing the world to some fine stylized patterns; but it is that haunting formula all the same. A thing is not reopened to thought or made substantively different by proof of having been undervalued in its kind, it is merely upped a notch or two in our tolerance, in its kind.

How far, then, does such an apparatus go to help us isolate the distinctive savor of American folk art, that which has nourished its myth through so many lean years of scientific inquiry?

II

In June, 1981, at the Fashion Institute of Technology in New York City, a display of American quilts was presented under the title of "Anonymous Beauty: Textile Treasures from Two Centuries." (Mrs. Lipman may demur that she was not talking quilts but her choice of them for "The Flowering of American Folk Art" seemed on balance to be fairly congruent with her points.) It was a handsome group, and the initial couple of turns around the premises exhilarating. The adroit needlework and piecemanship, the bold or dainty or "sour" colors and their dramatic or witty juxtaposition, the clarity and immediate accessibility of simple stylized design, the sharp distinct forms of elements and their kaleidoscopic or "repeat" or innocent space-filling proliferation—everything sensuously seductive and clamoring to be admired—could not be resisted.

But after those initial turns around, when one goes back in a day or so wanting more, a completer experience, the head

awash with some vision of a pure sweet art that must be verified, a chill sets in at the very entrance; though at first is put off. Because nothing has materially changed. The workmanship is as adroit as one remembers it, the striking colors and textures what they were, the simple formal patternings and clean-cut motifs as agreeable on the eye. Only, an excitement has drained away, or rather was never present: that core part of aesthetic affectingness which is tough cerebral fiber—complexity rather than complication or ingenuity—that is ultimately known instead of seen—that has as little to do with "sharp simple forms and bold distinct line, color and tone" as with the opposite strategy—that grows, deepens, concentrates to an integral weightiness. There is none of it here. One evidently exhausted the thing at first viewing, took more than what was offered, imagining that these charming textiles might grow, deepen, concentrate.

They do not, of course. They are Americana—demonstrations of "women's work," ingenious, sometimes tantalizing in their artful "imperfections," or a simple bold geometry which inspires the cataloguer to group some of them under "the very contemporary category of Abstract Art," but essentially innocent. Indeed, all the virtues of the American folk art quilt, as emphasized in numberless shows and books and engagement calendars, are here in abundance. One reasonably has no cause for dissatisfaction, except—well, one wanted more. And then, on the way up the aisle, as one turns dispiritedly for a last general impression, there, three-quarters of the way down on a divider, *there* is more: "Sunburst. ca. 1825. New York State. Cotton. 99" x 92" ... Cotton chintzes and calicoes intricately pieced."

No amount of care will insure a frequenter of American folk art shows against these oversights. The formula is bred into the response; taste has to be perpetually outwitted. What one has here is a quilt not made by rule of any of the standard measures. The quilting is hardly more than roughed in, its stitching loose, no more deserving of study than baste threads

on a half-made jacket (staringly white whatever the ground color). The sunburst itself seems too austere, lacking inventiveness, those little wiles of gratuitous discord to refresh the eye. There is no variation within the eighteen bands of its structure; they are somberly (not to say oppressively) regular; iconic. Added to which, the level of color saturation is far too dense, wanting in bold contrasts of value, for the traditional radiance. But perhaps most frustrating to the quilt connoisseur is that the artist has denied herself the prop of alluring fabrics, that sort of bonus in patchwork that can make us forgive a coarseness of the imagination. Some [of the fabrics], in particular three discrete bands of a putty-hued affair, are of a homeliness not often met with in these pieced spectaculars. They do not *decoratively* hold and justify their bit of surface.

But surface has been organized along different lines. The artist has "intricately pieced" together a picture for us. It may even be said that to the degree it is a picture—a rigorous subordination of the elements to an idea or mood complexly rendered—it is not honorably a quilt.

What is it doing among quilts then, you ask? Why, where else would it be shown under the formulaic rule of hierarchies. It has broken though the bounds of one sphere and not been provided for in another. As yet there is no official warrant for the existence of substantial art in a minor decorative mode, and therefore no certified way of making it out. Remember the old-world painter of fans: no matter how exceptional his wares, they are so with regard to established criteria of fan-painting, exceptional in their kind and by reason of the peculiar traditions of a craft which both govern and explain them. One may be entranced by superior technical flourishes but one does not look for more, feeling comfortable that otherwise these efforts are pretty much of the same depth. If (one feels) the fan-painter had nursed profounder ambitions, there were the serious media open to him, and he had only to get a square of good linen canvas or

a hunk of Carrara and enter himself in one or an other of the main events. We would then adjust our seriousness to suit.

In consequence of this bias, that the tacts are binding on workman and spectator alike, our profoundly ambitious "Sunburst," and (at a guess) some hundreds equally serious, have no recourse but to hang with the decorative Americana, since they will not yield to traditional canons of judgment. One is never prepared for, has never seen like, kind or equal of, can never lay in the expertise to summarily grasp an authentic triumph of the American folk artwork. Each in some respect is a unique type of organization, often combining the strategies of more than one discipline—being hopelessly impure—and demands of the viewer patience and a willingness to credit as *meant* what may look at first fortuitous or but culturally determined. Moreover, it has that nasty trick of similarity. It will come in conventional guise.

The "Sunburst," now. On the whole it impresses as middling of its pattern-type: not the largest of sunbursts nor yet the smallest, the most flamboyant nor yet the plainest, the most idiosyncratic nor yet—quite—ordinary: in sum, a way from prepossessing yet not—quite—negligible. Something in it will not let one alone. And so, after all the dazzle of virtuosity has staled on the eye, and all the bold distinct patternings have lost their innocent appeal, one looks back, hesitates, returns—and patiently, in growing deference, begins to make it out.

With that margin of grace American art viewers extend to almost everything but their folk art, one is able to tap, detail by middling detail, an aesthetic competence. Just how it might have developed circa 1825 in the outlands of New York State is not my concern here, and I would advise the sociologists and theorists of culture to look before they scorn. Because however improbable, it is nevertheless certain that the woman (or girl or granny) who labored that sunburst out of head and bowels, left

us a work of art in the high Western tradition. Not a "primitive masterpiece," or "textile treasure," but an original and fully realized work of pictorial art such as the nation seldom achieved in her day. The "clod" knew, or had wrung out for herself in the practice, by trial and error and the intuitions of an expanding intellect brooding upon them, fundamentally all I know based on four years of guided study at the Art Institute of Chicago, with two of art history under Helen Gardner and Kathleen Blackshear. Improbably, she found her own way to the "laws," and the proof of it is this oddly equivocal textile—as much painting as textile in the strategies of its composition. Miss Blackshear in particular would have had a field day stripping it down to terms.

The clue, the obscure something that won't let one alone, lurks in a sort of richness or depth of impression, nagging the mind even when the workmanship has been judged to be as undistinguished as the fabrics. The quilter, in other words, has got hold of us in default of two of her chief claims on public consideration. This seems perverse, in view of the fact that while bare of refinements the quilt is expertly put together, suggesting some doggedness of withheld powers; and that while the fabrics composing the sunburst itself are notably mean, the tumbling huge-flowered chintz of the border is notably lavish, suggesting ... one does not immediately see what it suggests. Thrift? Miscalculation? Humor? Eccentricity—?

Thrift, it quietly dawns. An artist's sense of it: the suffocating conventions scamped or displaced, but there in the letter, to modify visual habits without losing the interest. It was of course a commonplace of masculine procedure in the older schools. I doubt if it ever was much of a commonplace with women; and among queens of the minor decorative pastimes, vain of their traditional skills, geared to a narrow inspection of stitches to an inch or depth of a stuff-work or choiceness of a

calico, the self-denial of such jewelling must have been stared at. Why trouble to make a "best" quilt at all. What else was there to "best" but the finest of everything.

So however demure in the long view of aesthetic innovation, her liberties took some nerve. But this was a doughty woman with an idea in her head and enough quilting experience to indicate just the way it might—or again might not—be realized in its fullness. First and crucially, there must be no distracting hand, or signature work, to divide the interest; all must be as impersonal as she could discover how to make it short of noteworthiness, as unnoteworthy but as mortar of a continuum. Second, there must be no distracting beauty of fabrics, or at least towards the center where a fine show was typically arranged, since at the eye of an explosion (the place of intensest radiance) nothing can or ought to be distinctly seen. Plain bright red and yellow rings alternating around a plain bright yellow star; grey-yellow then, as might occur in optical reaction; a putty-lathered blue; pink, hard against deep, deep blue, on the order of a counter-reaction;—and so on, pattern beginning to complicate and usurp notice to the degree that color starts progressively to lose it and subsides in ring after ring of sand tints and dulled blues towards a night-blue border. Which is no mere formal frame but consequence: resolution—yet, strictly, a border too. It appears the idea was to translate the visual and emotional effects of a sunburst (a "big bang" in the metaphorical sense) into the small artisan language of a patchwork quilt, and in the course of achieving a compromise the woman proves herself endlessly resourceful.

I have mentioned some haunting richness over what can be accounted for in the plain techniques and units. A problem is that one does not at first take in the variety of her means. She is not solely concerned with the articulation of hundreds of snips of commercial fabrics, but as much with far smaller entities, the nuclei of disjointed and aimless pattern within them, chiefly of

the simplest figurations. She exploits these loose ends, often independently of their settings, with the most suggestive refinement. That border: a showy chintz studded with large, representational, free-wheeling flowers—lilies, roses, dahlias—and so out of scale and mood with its schematic centerpiece that one tends to dismiss the thing as decorative folly. Yet after much puzzling it continues to hold its place and, though still perhaps *decoratively* queer, begins to feel *organically* justified. This is scarcely what one has come prepared to deal with in a "best" quilt. Guardedly, one modulates from a minor to a major alertness— judgment by resonances rather than by eye alone. At this one begins to sense, quite before one sees, that here is no ordinary outwork to a decoration but the space of an event, and as such a condition of the event. One now observes the meticulous dissolving of the patterns of the final ring into the secondary border patterns, ochres liquefying and running with ochres until there is no edge, an oddly romantic device in these hard-edged formats. And then one's eye returns to search with new readiness over the medallion proper, and the mazes of blue nuclei begin to pierce back, as if limpid above a uniform ground, as well as to link up in transverse patterns: for in fact the night-blue border is schematic air, to be read as a total enveloping. And all the pretty garden flowers? Schematic maelstroms of the solar dust: moons and planets to be: yet flowers too, a border, a length of chintz. A sunburst within a "Sunburst." A powerful image teased by cunning from some calicoes and flowered chintz.

Altogether, then, a serious effort of the imagination, at once measurably below and impalpable spheres above the level of our best piecework. Below, in just those nice details of craft and sentiment, of serene and stylish pattern-making, for which we go to quilts; above, in just those things for which we are not used to going to them, depth and complexity, resonance, headwork and heartwork and paradox. It embodies the challenge of much quintessential American folk art: the difficulty in finding

its terms, not alone what it is up to but how and why it succeeds (when it does), on what general rule.

Well, we have the formula. And on trial the most glaring irregularity to be noted is that "Sunburst," for purposes of a rough sorting out, checks with none of the categories of either tradition, being neither a correct decoration for the bed nor a true tapestry nor fully a "painting," though with gestures in each of these directions. It is in some bewildering way utterly brought off yet imperfect, incorrect. As a quilt it is much too ambitiously organized, with an edging vital for resolution, to forfeit a third of its area down the flanks of a bed; while the exposed center portion would be magnified in all its bareness of means and fabric without benefit of the pictorial rationale. One wonders about the wall. But as a hanging it is both too densely unitary—too like a sunburst quilt, in fact—and too intimate in the nuanced work of its composition, to interestingly hold a wall. Again as a painting, it seems short of some bottom credential. One at length reads it: marvels: goes away: and commences to doubt. The impact is there but not enough there for art in a major mode. The thing is veiled, elusive. It approaches the line but will not cross over to us. It wants some finality of stress, of distinctive temperament, of performance values—awareness of *us* and *our* stake in the experience, *our* opinion, that is so crucial a factor in Western aesthetic response. Chillingly, the woman seems never to have considered her temperament and our response, just the work in hand. That is now what we have come to crave from major art.

This lack or refusal of self-conscious style would appear to bear out a major insight of the formula. She shares with folk craftsmen of all times and places a bred-in-bone conservatism, inhibiting her expression and freezing it, despite her ambition, at the decorative level. Our uneasiness with "Sunburst" is now vindicated. Temperamentally it is fancywork, rather more artful than most but by definition an exercise, and it simply cannot

measure up to our demands on major creation, which must half-way meet the eye and impassion the blood with responsible major temperament.—But though it may not half-way meet the eye and impassion the blood, it is not therefore fancywork. This projection backward from the formula, to relieve ourselves of some uncertainty or ambivalence of judgment, a hindrance to tabletalk, has been the nemesis of American folk art: if it is not one known thing, full-fledged major art, it will be the other known thing, minor or decorative art, on the principle that with so many scholars around all things must be settled and known.

Not quite all of them. There are two conservatisms buried in the term, one of manner and one of substance, one public and one private. In a healthy folk aesthetic, coterminus with the public norms, both are fused in a single unruffled discourse along the surface. What one does not see is not there. American folk art, again—the vein of it exemplified in "Sunburst"—was a mutant phenomenon, a sort of malady, not a new species but a gathering new set of drives in tension with old and still profound social tacts. And that tension, the containment of expanding powers within an orthodox framework, like concrete laid over seed, humping and cracking with ferments, concentrating the force, gives it a quality of some discomfort to fine art connoisseurs, who are not attuned to the underground life and its muffled ecstasies.

There is a touchstone that enables us to dispense with another large folk attribute: public orientation; art produced by and for the tastes of a sovereign community, to be reabsorbed by it. Considering our slow sense of its values, "Sunburst" would have passed like an undetected pearl through the communal gut. It pretty clearly was not worked for locals, or not after a certain stage in its development had been reached and fathomed and the true adventure begun. Nor does it seem tenable that the woman had hopes of understanding from her superiors in the hierarchy—the painters of the schools, or even the itiner-

ants who regularly came to the door. In the States ca. 1825 these grandees would have been as unresponsive as family and friends to the nature of her investigations; but allowing that one or two had been qualified to make it out, her "conservatism" overall, the absence of hand or temperament, the familiar pattern-type and means of display, were hardly calculated to draw the attention of a fine painter of portraits or over-mantels.

The circumstances of society that would have provoked a "Sunburst" are, of course, open to speculation. A number of traditional glosses are always possible with the wherefores of a thing, since we can never accurately prove (or disprove) them. But there can be no two ways with the startling result—its headlong leap of mind beyond the treasures of the F.I.T. show and almost certainly beyond the craftwork of its age and region, yet with the unlikelihood of its ever cultivating a more perceptive audience, which did not then exist for it. At a guess, she ended laboring for nothing but the wonder of it to her own eyes, rapt in the exhilaration of watching a half-invented, half-recovered beauty grow, and herself leave earth—her New York State community at least—under magic of her now flying fingers, unbasting and adjusting patterns in accordance with some high pictorial urgency, austere and aristocratic, unfolding to her as the work unfolded, and such as her betters had all but lost the secret of. High pictorial urgency. On balance I may appear to have done little more than *back* "Sunburst" into the sophisticated culture, or in wishful orbit around its ideals. The woman, I may appear to be saying, had left one gravitational field for the other, under the old-world law for precocious talents, too large and unruly for the system into which they were born, and her strivings must be viewed in context of the high art of her day. Along with the rest of her breed she was endowed with some natural genius peculiar to our shores and a brain worthy of Leonardo.

But I *have not* said that. I am aware of no particular

genius in the woman, and on the evidence of this single quilt her brain, though remarkably active, seems of no better stuff than yours and mine, should we push them to the utmost of their powers and commit them to a trial as she did. No, that her "Sunburst" can reward attention is not owing to abnormal or special capacities. She was not born an artist, and her quilt, riddled with imperfections and unfinished business, is far from being a masterpiece in Webster's sense of the term. What it is precisely is a specimen of an authentic new art of the common people, as against the decorative crafts of the folk—new, because there never was a free-floating common people in the world before, and because there never was such a void and tenuousness in ordinary lives to galvanize the effort.

As to its reaching for values to the sophisticated culture, I am put in mind of a little carving of a horse I saw nearly a decade ago at the Rockefeller Memorial Foundation in Williamsburg and have not seen since. It was a notably crude job of work, stark and rough-chipped on four ramrod legs and with a lowered neck part way to being a giraffe's. It was puerile as the image of a horse, rudimentary as sculpture. The carver showed few natural capacities for such work, and his brain had little power to conceive and implement complex strategies. Yet while I have long forgotten all else on exhibit in the room, in every instance notches above it, I would hazard the guess, in regulation brainwork and aptitude, the little horse recurs again and again to memory. It nags the vitals, as "Sunburst" nagged and drew me back to question it. In some integral, immeasurable way it is a deeply considered work of art, brainwork of a private and irregular order. The phenomenon can be experienced; but hardly demonstrated or otherwise than to say it has the numinousness fundamental to any plastic art form, the "aura" after all meaning and artifice have been fathomed and absorbed, when at length the thing comes on us whole in irreducible objecthood. Jean Dubuffet has written: " ... There is in modest, rudimen-

tary, but strongly motivated works of art, uncontaminated by the prejudices of our so-called artistic culture, an electric charge that you will never find in 'high art.'" This of course is neatly self-serving, and the decisive "never" is hogwash, for Dubuffet himself I would imagine. But his "charge" is something of what I mean—a gradual one in many cases, intensifying to a sort of steady rapturous ache—a super sanity, a sense of "holding" in John Berger's definition, rather than mad excitement—and is our ultimate debt to all true artistic creation.

Now, I propose that the childishly simple horse and the cunning and complex textile are of an essential nature; that that carver was of one school with that quilter, and their products, equivalent both in reticence and "charge," are also equivalent as gauges of what is singular in American folk art, defining each other across the years and genres and disparity of gifts.

And how do these products, outside the pale of a folk tradition, sort with products of the dominant culture? On every count but one they are again outsiders—not at the periphery but well outside, off in some third system of their own. Neither represents an aesthetic current whose biases can serve as an index to its assumptions, enabling us in some degree to set it and judge whether it is near or far from recognized goals: neither, therefore, can be wrapped up as either innovative or traditional with reference to an historical process: and neither, therefore, can be used to assess related object-types or be assessed by them—neither, by formulaic measure, is superior or inferior, or advanced or retrograde, to something else of this group but quite simply inconsequent to it. For one thing, neither shows concern with measurable (competitive) techniques and in the instance of the horse is behindhand in even basic preparation. For a second, neither respects the tact and conventions of its function, the textile being boldly misconceived as a cover for the bed or for any other prescribed use or means of display—the carving

Selections from
The Howard Rose / Raymond Saroff
American Folk Art Collection

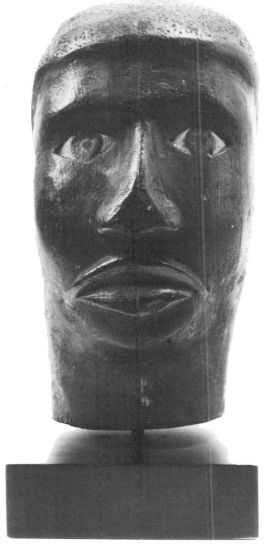

Head. 20th century, 12 × 6″, polychrome wood.

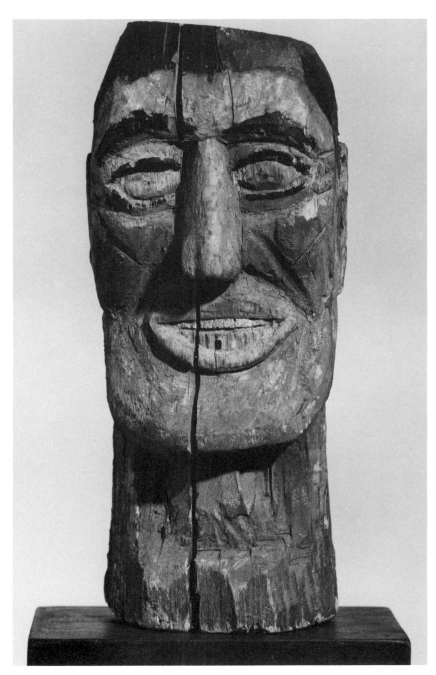

Head. Circa 1930, 11 × 5″, wood.

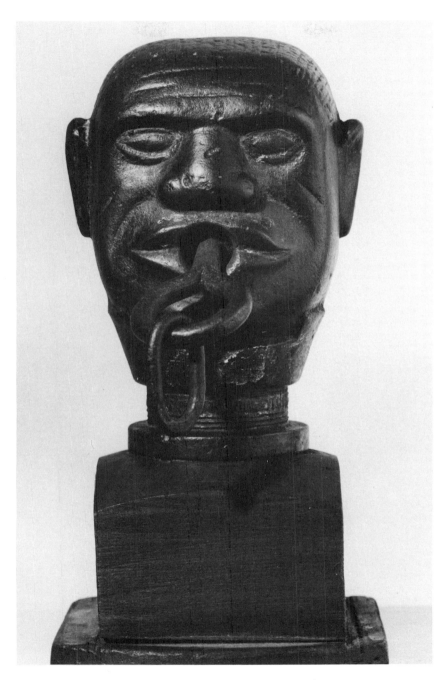

Hitching post head. 19th century, 10½ × 4½, cast iron.

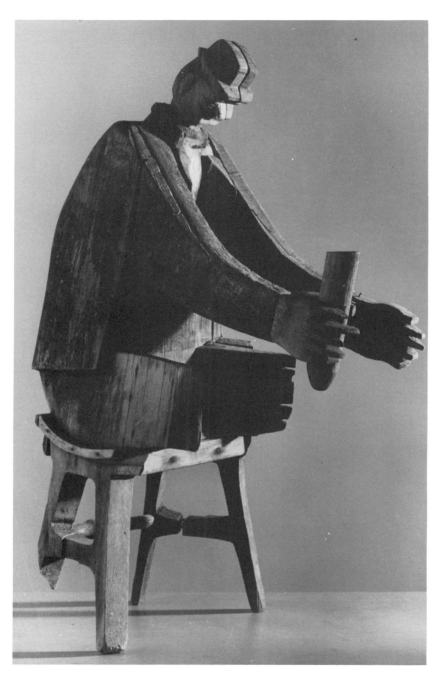

Trade sign. 20th century, 20 × 10″, wood.

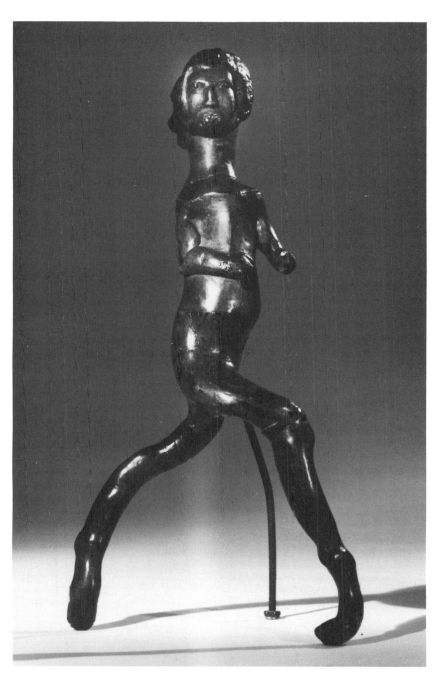

Janus figure. 19th century, 14½″ high, root.

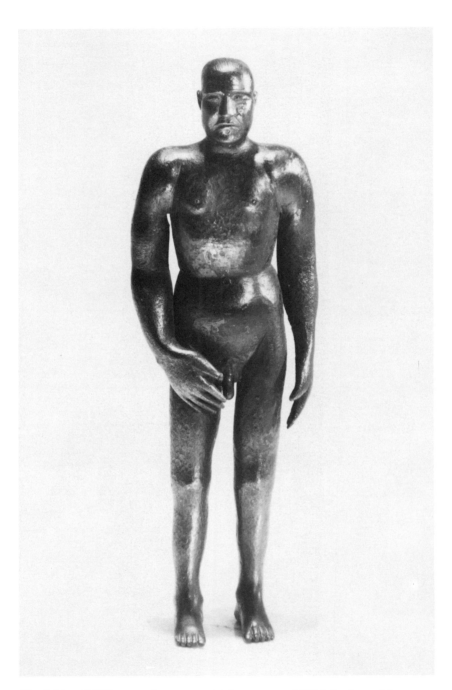

Hugh David Ellington: Iron man. 19th century, 10″ high, forged iron.

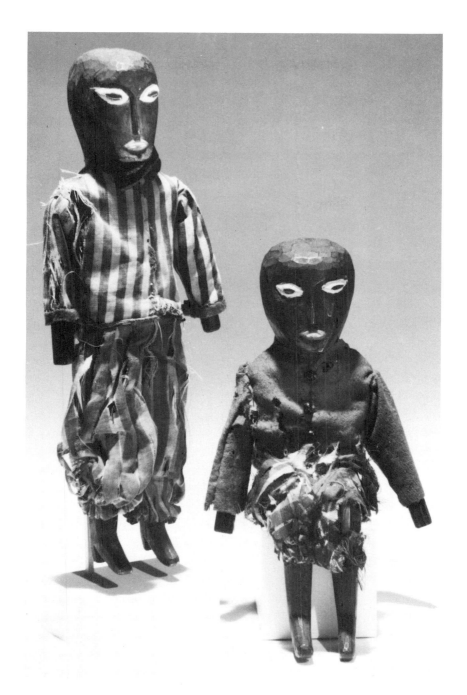

Two articulated dolls. 19th century, 10″ high, polychrome wood, fabric.

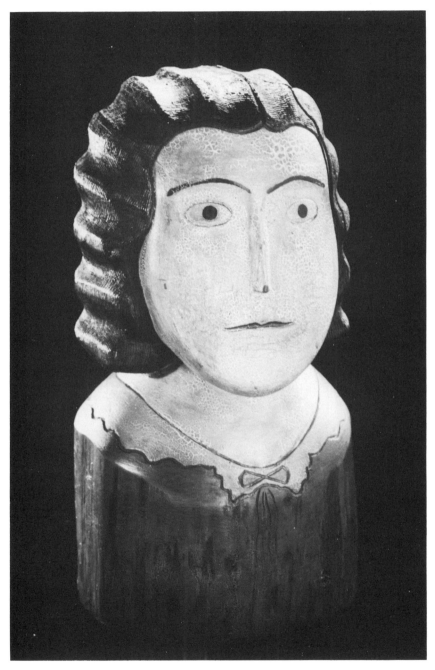

Bust. Circa 1930, 13½ × 6½″, polychrome wood.

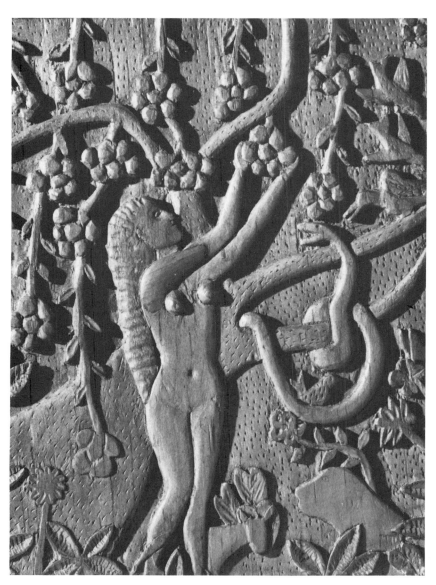

Eve. 20th century, 8 × 6″, wood.

Althof Bergmann: Liberty Bell Centennial toy. 1876, 11½ × 5¼", metal and fabric.

Althof Bergmann: Horse and rider toy. 19th century, 13 × 14", polychrome metal.

Larkin Scull: Horse and trainer. 20th century, 13¼ × 11½", polychrome wood and leather.

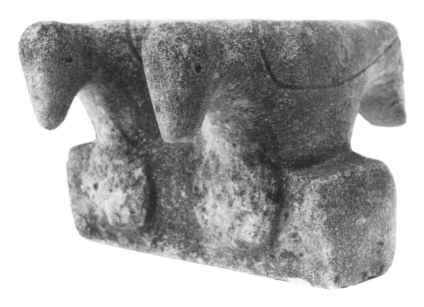

William Edmondson: Birds. 20th century, 8 × 10½", limestone.

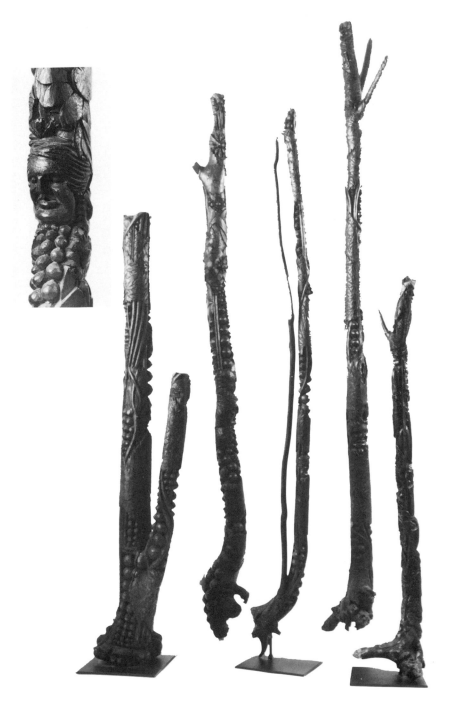

Trees carved with grapes, grape leaves, and Bacchus faces. 19th century
(Mohawk Valley), to 65½″ tall, wood.

too grim and static as a toy, too crude and toylike as an ornament for the mantel, too small for its discourse and too large for its skill: each, in fact, as remote from perceptual and conceptual rules of the *bon ton* as it can be.

By virtually every cardinal test of the game they are wanting, but one. An unsettling one. They share with achievements of the other art some culminating fullness, or integralness, inaccessible and all-justifying, which is said to be the *overage* of skills and talent and historical bearings, work grounded in a transcendence of conditions they have failed even minimally to satisfy.

To a formula-haunted mind the claim will seem too fatuous for rebuttal. Leave aside the clods then. Earlier I mentioned Goya and Copley, undoubted masters whose weak brushmanship and draftsmanship, respectively, queer the impact of some of their paintings, just as the formula cautions. The eye, exacting technical assurance as a matter of course from these great ones, is jarred off its study by an artlessly outsize head or the smearing and scumbling in of entire tracts of a composition. It is officially work by a master but is not master work, and though of interest on the strength of blood ties with certified master work, in itself, as experience, it fades into the half-achieved, institutionalized world of museum sludge, called the fine art tradition, that has all but embalmed us in second-rateness.

Again, in other of their paintings with comparable or worse impairments, one can observe in oneself the tendency not merely to accept but not at first to see what is so disastrous elsewhere. Only after considerable charge has been received, and then incidentally, side of the eye, do we begin to make out the familiar botching. But it is another thing in master work. In the case of Goya we may go so far as to attribute it to a visionary leap of style, a proto-modernism, allowing a range of expression not available to academic correctness; or else we may speculate

that it was Goya's good fortune (and ours in his) to be technically limited, since it might have been this—his struggles with this—that backed him towards the pungent Goyesque.

Yet one of the symptoms of this expressiveness is just the destructive factor to less than charged expression. And so it would appear that mastery of the means, the utmost measures of deftness and aptitude, is not or is but conditionally the precondition for major art; that only a super-added something, some all-justifying power of transifguration, is invariably present. And the possibility then suggests itself that this all-justifying power exists rather as a separate capability than as the sum-plus-x of mastered preconditions, since a majority of exemplars of the means never attain to it, and a few produce major art lacking some of the means. For it is striking that inexpertness functions as such only in unsubstantial work, which is then seen to be unsubstantial because of it, while in fully saturated work this inexpertness can be seen to function as strength, at all events—as in Copley's dwarfish "Paul Revere"—is transfigured and neutralized.

Won't do, you impatiently head me off. You see what I am building to and are there before me. For the sake of argument, a certain craftsmanship may be short-cut ... but not aesthetic sophistication, that knowledge of an accumulated and accumulating lore on which all major art has fed and has in turn modified. It is worthless to tilt at attributes and gloss over the substance of the thing: deep tradition; the formal or expressive problems and solutions evolving out of each other, solution out of problem and fresh problem out of solution, in an unbroken chain of dependency on what has gone before and responsibility for what is to come. No art has a call on importance that stands altogether outside this chain of dependency and responsibility. It is agreed that major art is the art that pinpoints the major cultural imperatives of its time (agreed to be the major imperatives by the major artists) which are simultaneously at the center

of its own historical process (afterwards agreed to have been at the center by major critics and historians). Major art satisfies those imperatives in a way which, for the *time,* happens also to be pregnant with major development for the process, whether in furtherance or reaction. Now, this may seem very convenient and remarkable, that the imperatives of the time should exactly synchronize with the rigorous problem-solving and problem-generating of art history, but such is the case. What is decided to be done, and for whatever motives (or lack of motives, or confusion, or perversity), can always be demonstrated to have been what had to be done, if the tradition and society were to carry forward. Major art, then, is major process, the crystallizations of it being actually of less significance to the culture than their mediatory roles: what they came from, what they led to— what they led to being of less significance than what *they* led to—*ad infinitum.*

Do I mean to claim that a species of discourse totally without such dependency and responsibility—that is to say, without historical consciousness of what has been done and requires to be done, which has the barest feeling for the movement of its time, that is to say, for what culturally is and is not serviceable, what in its style keeps pace with the evolving social (or power) enterprise, civilizing it to just the extent that it can (or will) then tolerate, which, standing free of such movement, timeless, placeless and (therefore) styleless, must always be culturally barren, at once as old and as new, as civilizing, as serviceable, as a meteorite through the roof—do I mean to claim it should have equal rights of attention with major art?

I was not building that way. American folk art is not in the same universe with major art. Its equal rights to attention do not stem from importance to the culture, *i.e.* historical process, but just from a cultural unimportance that yet provokingly stands its ground, and not alone that, created the ground. I have tried to indicate how in all but one particular the means and

ends are mutually exclusive. At no point—omitting that particular—do they coincide; at no stage of formal or expressive development, advanced or rudimentary, is there the suggestion of a common language, however broad. If "Sunburst" appears to manipulate certain idioms of a fine art character, they are not consciously so but rather intuitive discoveries of primary laws, out of their time and place, inappropriate as to genre, without the signature and consistency of a style, eccentric, in brief—eccentric to either pole of the formula.

Indeed, the habit of displaying amateur or boggled fine art among our folk wares has the instructive effect of making it look even flimsier than it does in its rightful company. There, at any rate, what is wrong with it is measurable by known criteria, and its distance from the ideal can work to advantage, pointing up a certain warmth and charm of temperament or catchy rhythmicalness, or boldness of attack, giving it a sentimental edge over its bourgeois betters. Among chill, crabbed, aristocratic American folk art, however, these seductions go for nothing. The rhythmicalness turns vulgar, the warmth and charm distasteful, while the "boldness" of attack sours into a ruse of one who couldn't do the thing as he would have liked.

No, something else is ideal here, but is less to be seen than experienced. Any addicted folk art collector goes weak at the vibrations until he possesses the agent of them—*has it firmly in hand*—though what his experience is he may not be able to tell you. And he will run away home, set it with as unstylish, unforthcoming and hodgepodge a group of curiosities ever witnessed, and know then—not see—that it is in fact of their lineage.

Weight. Dubuffet's mysterious charge: force of entire commitment to capturing a presence in the mind in which all one's half-thoughts and divided energies feel to be converging in a significant weight—to get the weight out and true, anyhow and by any means, (for it is weight that is crowding), this once

to affirm one's unclassified unsupported presence on the earth. Though one can't make out the image of that presence, since a mere bunching of desire, one will know when one has captured it by the weight. This must exactly correspond and the image will be near enough.

And this anyhow-imaged weight, this grappling it out, this dense reduction to form of all the potentialities of a life—not more (which is decoration) but not less than all—and as such (plenitude) as electrifying in the misshapen little horse and "Sunburst" as in Michelangelo's "Night" or Cezanne's standing male "Bather" or some black and white diamond of Mondrian's—this sheer freightedness is what distantly but palpably connects the best American folk art to the major examples of the major tradition. Not to the process but to those fierce concretions that are largely useless to it, that link together across schools and styles and call its value assumptions into question.

As to the formula, it makes no provision for these heavies. There is master work, of course, produced in a vague sphere of genius somewhere beyond the stretch of skill and sophistication, though presuming them. Yet this sphere is problematical. It seems to have little to do with gifts and capacities. Cezanne and Michelangelo and Mondrian were very unequally gifted, yet they produced work of roughly equivalent charge. Van Gogh's drawings show none of the natural gift and acquirement of Rembrandt's, yet they stop one dead with equivalent charge. So it is weight after all, that existential utterness and saturation of the thing, the capture and focus of all one's real significance in putting down a line.

And yet this passion for correlative gravity (Ryder called it a coming to the boil, Yeats the clicking shut of the box) which is the aura of our greatest art, is not *sui generis* an artistic passion. It is a broadly human one, the whole art of the life, and can as well issue in a Lincoln or Brown or Thoreau as in an Eakins or Ryder. Or it can result, under desperate conditions of rootless-

ness, in a breed of transfigured clods, rooted in themselves, committing dense charged thingummies that tear holes in the professional culture, sinking right through to bedrock laws to a place some distance off from master work but not too far in absolute weight of presence.

Therefore, while conceding that American folk art is all but nondescript under the prevailing value-system of the dominant art, I do, yes, enter a claim for its rights to serious attention. Perhaps I should rather say I enter a plea for the reconsideration of a value-system that excludes it. It is, when all else has been picked apart and laid to rest in the process, *the* enduring life in artistic discourse, that which makes the always-new experience, that which after long acquaintance (it brooks no friends) and much interim evolution in taste and fashion will always stop us dead in surprise.

3 An American Beauty
Mary Ann Willson (active 1810–1825)

"The artist, Miss Willson and her friend, Miss Brundage, came from one of the Eastern States and made their home in the Town of Greenville, Greene County, New York. They bought a few acres and built, or formed their house, made of logs, on the land. Where they resided many years.—One was the farmer and cultivated the land by the aid of neighbors, occasionally doing some plowing for them. This one planted, gathered in, and reaped, while the other made pictures which she sold to the farmers and others as rare and unique 'works of art.'—Their paints, or colors were of the simplest kind, berries, bricks, and occasional 'store paint' made up their wants for these elegant designs. "These two maids left their home in the East with a romantic attachment for each other which continued until the death of the 'farmer maid.' The artist was inconsolable, and after a brief time, removed to parts unknown.

"The writer of this often visited them, and takes great pleasure in testifying to their great simplicity and originality of character—their unqualified belief that these 'picters' were very beautiful, (and original) (they certainly were), boasting how greatly they were in demand. 'Why! They go way to Canada and clear to Mobile!' They had not the slightest idea how ridiculous they were—Their perfect simplicity and honest earnestness made them and their works more interesting:—*sui generis* without design,—

"The writer of this little sketch does not mean to compare these mineral and vegetable compounds of fantastic taste with the modern artistic works of a Cole, Durand, Huntingdon and others—but simply as the work of a native artist —uneducated of course, but a proof of the unnecessary waste of time under old Masters and Italian travel.

"The reader of this will bear in mind that nearly fifty years have passed since these rare exhibits were produced—before 'education' had taken such rapid strides in the 'picter'

71

world—and now, asking no favors for my friends (as friends they were), let all imperfections be buried in their graves and shield these and them from other than kindly criticisms—"
—"An Admirer of Art," circa 1850–60

"... They were supposed to be sisters, but in fact were not related by ties of blood in any way. They had both of them, in their younger days, experienced a romance that had broken their hearts, and the bond of sorrow between them had drawn the two close to each other in womanly sympathy. Together they had come from the old country to Connecticut, and from there to this place, seeking peace and forgetfulness in the wilderness. They never told their story or anything in fact, relating to themselves, that could serve as a clue to their identity or past life."—R. Lionel De Lisser, *Picturesque Catskills, Greene County,* 1894

Sometime during the 1940s a portfolio of twenty bizarre watercolors by a woman signing herself Mary Ann Willson came into possession of the Harry Stone Gallery in New York, Enclosed with the suite was the above scripted memoir by an Admirer of Art, on its internal evidence ("the more modern artistic works of," etc.) dating them to the first quarter of the 19th century, an era in provincial American watercoloring characterized by tight poonah and/or embroidery techniques. But Miss Willson's watercolors were neither poonah nor embroidery influenced. In fact they have so little period flavor of any kind that according to N.F. Karlins, in her useful monograph for *Antiques* (November, 1976), "there has been speculation that the paintings and accompanying document were concocted in this century in order to benefit from the growing market for folk art. However, this is not the case, for Mary Ann Willson is documented in R. Lionel De Lisser's *Picturesque Catskills, Greene County,* which first appeared in 1894" —see above—and which reproduced two examples of her work, since vanished, of undeniable resem-

blance to the hand in the Stone Gallery portfolio. Now it is just possible that a forger studied the compositions in the De Lisser book and extrapolated twenty others on the basis of them, but not at all likely. For one thing, while "in the hand of," the De Lisser works give no inkling of the explosive willfulness of the Stone Gallery papers; the larger indeed, "Ruth and Boaz," is decidedly in the stitch-stroke idiom. That is not the way with petty forgers who whatever their liberties of subject are fairly cautious as to earmarks of style. For another, no petty forger would have been content with duplicating so little natural talent or have had the powers of mind to transcend it in twenty original (they certainly are) and perfectly hair-curling assaults on Taste.

So the art seems genuine enough—e.g., product of the 19th century—even if its maker, her person and background, continue to mystify. The two accounts at the head of this chapter (there is lately a third: a message discovered in 1967, unsigned but said to agree in tone and penmanship with the memoir by the Admirer of Art) are curiously at odds. One starts her wanderings with Miss Brundage in an indeterminate Eastern State, the other specifies Connecticut but puts their origins back to an indeterminate old country. One frankly posits a romantic attachment (though the phrase did not then signify all or only what it now does), the other a bond of sorrow and sympathy due to separately broken hearts. One tells of their "simplicity" and "honest earnestness," implying a measure of intimate exchange between them and the writer, the other asserts "they never told their story or anything in fact, relating to themselves, that could serve as a clue to their identity or past life."

No clue to their identity. Pretty clearly then there were grounds for suspecting that Mary Ann Willson was not "Mary Ann Willson" nor her Miss Brundage a "Miss Brundage." Furthermore, to go by N.F. Karlins, they seem not to have "bought a few acres." "Since neither woman is listed in the local records at the Catskill courthouse or in any census of Green County, it

is possible they were squatters. Several Brundages do appear in early Greene County records, but none can be identified as the Miss Brundage under discussion. Perhaps she and Mary Ann Willson came to Greene County because a relative of hers was already living there." Weak, very weak. Permitted to squat on evidently desirable farm land—there were neighbors nearby to help with the plowing—over an interval of many years? I wouldn't think so; at least it is not my experience of the American temper. As for Miss Brundage going among relatives presumably with some knowledge of her identity, it seems hardly consistent with her precautions otherwise. On the other hand, one might adopt the name of Brundage where Brundage was a familiar and respectable sound. . . .

Murderesses out of Genet's "The Maids"?—Mme. Vigee-Lebrun with some menial in flight from the Terror and a little shaky of hand?—Defecting wives? —Escaped lunatics?—Stranded British agents?—Dudgeonous opera singers? —Or did they exist? Were they after all a fiction of the Admirer of Art, who is generally regarded as being the source of all three accounts? It would enormously complicate the business of scholarship to be saddled with an authentic body of work and a forged artist—how does one X-ray a forged artist?—but there are symptoms that point more to novice romancing than to a spontaneous narrative of facts.

In her piece on Willson for the catalogue to "American Folk Painting of Three Centuries," Jean Lipman writes of them as offering "exactly the same sparse information." But as we have seen, the information is by no means the same, though the *areas* of information are. Since they appear to have been written long subsequent to the event, and at different times, it is odd that there should be no filling in, no involuntary memories, but only the restatement, down to a single quoted sentence and a couple of vernacular words, of a few bits of intelligence. Moreover, the bits of intelligence are subject to extremes of percep-

tion. I suppose one does not usually observe of conspicuously evasive people that they are honestly earnest. Or that hugging and kissing and God knows what are tokens of a womanly sympathy strengthened by bonds of sorrow. This is free and perplexed invention by someone in whom the faculty was small. The Admirer could not make up his mind about his characters—for instance, what sort of woman, in his narrow experience of women, would have been apt to have done those outrageous paintings, found strewn among rough furniture and moldering dresses in a deserted cabin he entered, one hot noon ca. 1850–1860, in quest of a swallow of water.

—Even by the dim light of heavily curtained windows he could see that the dresses were separable into *two* wardrobes. No pantaloons or jackets in evidence. *One bed* and one *twin-size depression* at the middle of it. Mother and timorous daughter? A pair of fond sisters? Once more his eyes take in the muffled window-openings, then, his lips a little moist and parted, his breathing a little heavy, he peers in a kind of alarm at that *one twin-size depression,* no, scarcely twin-size, the width of two bodies in *claspéd loving embrace*—and *deep,* the depth of *many claspéd years*—and still reeking of *sweat* (he discovers, sniffing at it), the sweat of *many....* Fainting, sobbing, he turns and bolts through the door, only to shin himself and go somersaulting over a rusted plow obscured in high pigweed near the threshold. He squalls and throws his arms across his face in terror, for it is a peculiar looking plow, all fretted and webbed with rags, which at first glimpse he takes to be a huge if somewhat emaciated grizzly. Hobbling up to it at length he sees that the weathered tatters had been *ribbons,* tied in bowknots at close intervals along the handles and beam. *A woman's plow.*

He lowers himself onto the beam in order to chafe up circulation in his numbed leg, and as his breath comes easier his eyes regain their inquisitiveness. He moves his head this way and that and before long has picked out the distant stone walls

and estimated the plot at between six and seven acres, most of it tillage now gone to weed. Through an association of ideas he then glances down at the ribboned plow, observing that while in spirit it was plainly a woman's, in size and heft it was a man's, and that to work six-odd acres with such an implement would have required a woman of Amazonian proportions. Now, with distaste in his features but with mounting enthusiasm, he recalls the *twin-size depression,* settling with himself that the ladies would have been at least physically normal. They must have had help—the neighbors perhaps. But with their doings?—Sisters.—To be sure. They would have passed themselves off as sisters, or not have contradicted the notion. All in all they would have been tight-lipped about their identities.

Yet even as his brain ignites with the story a certain gravity darkens in the Admirer's eyes. The solitude and oppressiveness of the scene begin to get a hold over him. The wearisome farm land, the coarse conventional neighbors (he has no doubt), the shallow picturesque of the countryside, of the country itself, the utter flatness and staleness of spiritual life in the great democracy, which at junctures before now has seized him with misery at his empty days, all is given a turn of the screw near tears alongside the rebellious image he has been conjuring. And what must once have been their misery, those godforsaken sapphists, with the whole might of university obloquy at the very door of their cabin, waiting under their windows—(sniffing at the bed!)—outcast *in* paradise—what must it have been to sting them to such an adventure?—Those paintings, now, full of a lush almost Eastern fantasy, garish and queer as sights of the first morning—and yet to be named—thinks the Admirer, getting abruptly to his feet.

As he does so a man rears into ken less than a quarter of a mile off in the adjoining pasture, lugging a stump by one of its roots, and who chancing to look across as the Admirer stands

clear of his covert, stops and waves to him. The man hesitates, as if not unwilling to come along and jaw if summoned, tell what he knows. The Admirer also hesitates—for but a twinkling; whereupon he brusquely gestures the man on his way, steps around the plow and reenters the cabin. He is quick with his work. In under five minutes' time, pale with mission, he comes bounding out with rolls of watercolors stuffed into either pocket. The man with the stump has meanwhile abandoned it and approached the area wall, and now, one leg astraddle, again waves and indicates a willingness, indeed it begins to appear a determination to be friendly, but the Admirer ignores him and hastily rounds a corner of the house to get back on the lane. En route he pauses—briefly, for the man is braying out to him and probably coming on at a gallop—to examine a minuscule gravesite, about one by two feet, doubtless a pet's, at one end of which is a primitive wooden cross bowknotted like the plow with weathered ribbons. He dips to make out the traces of a pencilled inscription on the cross-piece: — R (or P) — N (or M) — AG (or RQ) —. *Brundage,* darts through his fevered mind as he hurries on, the milk-woman's name, and the postmaster's name, and the Elder's name.—But he has no sooner set foot in the path than the oaf lumbers into view, his face beaming with stale, flat information—a damnable research fellow!

"Mister—haloo, mister! Wait on, if yi've a cooriosity! I knowd um wal—!"

The Admirer, a reserved and gentlemanly sort, can never afterwards recall it without a shiver, but the incredible truth is he pulls up dead in his tracks, flourishes his bony fists and roars like a lion: "I'll cut your throat if you dare utter one word to me, you Peeping Tom!"

It stops the oaf dumbfounded. *'Who's* a Pippin Tom! I knowd um 18, 19 year —oandly jis' live acrost the field—!"

"Brute! Liar! Nobody knew them! They await their

birth! I swear I'll have your blood if you don't leave me this instant, if you impart one syllable more of your pernicious slanders—!"

"Wal," growls the brute, turning to go after eyeing the packs of watercolors which the Admirer has made a clumsy move to conceal, "I *cud* mush yur soff head in, but I reckon I won't. Pore work fur a man to be doin'."

"Yes, yes, back to your stump with you, farmer."

"Sure, and back to yur robbin' wuth you, perty gent. Movin' on thet way? There's a grevyard up a piece wuth a new-berrit widder leddy. Tuk a cantlestick down wuth her, they tell. Mought be worth somethin' too—"

The Admirer colors hotly and strides along. Just the stale, flat remark one could expect from a stale, flat American, but the deliverance had been worth it. He reaches his village, some dozen miles off from the secluded farm, in owl-light, and as he walks up the street to his bachelor dwelling he is rehearsing phrases.

"The artist, Miss _____ and her friend, Miss Brundage, came out of immemorial Egypt, where they had been virgin-attendants at the Temple of ... no. The artist, Miss _____ and her friend, Miss Brundage, wended down one morn from the forbidden Black Hills of India, where they had been ... no—can't have it. Some drudge sure to check out the census. The artist etc. etc.—out of—the East—better, but vague—an *Eastern State*—yes; good. Check that O drudge. The artist, Miss _____"

But his interest has become engrossed by the tall, large-gaited figure of a woman hurrying before him and soon lost among the shadows of overarching trees. Her hair is white, her garments mourning-black, and from her arm depends a hamper topped with what he conjectures to be fine linen with heirloom lace at the edges. Indeed she had gained the street along a path issuing out of his own kitchen yard.

"Mary Ann!" he calls, putting up his hat in the vestibule and taking a moment to frown severely at the Asher B. Durand painting near the parlor entrance, titled, "Autumn Splendors with Waterfall, Mossy Boulder, Blasted Tree and Sleeping Pheasant near Old Harry's Gulch in Upper-Middle Greene County, 41 Miles Due West of the Mass. State Line, New York, Nov. 16–28, 1847," which for years has been his model of poetic beauty but at the moment strikes him as so viciously stale and flat and *accurate*.

Mary Ann appears from the kitchen, her weak eyes cast down. She is a plain, rather heavy-set young woman with lustrous hair drawn into plugs over each ear and the simple address of a child.

The Admirer tosses her an equally severe look and heads across for the staircase. "I'll have supper in my room."

"Yes, sir."

"There is a letter I must endeavor to draft. Let no one disturb me."

"Hardly no one tries to. Godspeed, sir." But as she moves to withdraw:

"Mary Ann!"

"Sir." Turning simply.

"Who, pray, was the visitant to my kitchen a short while ago?"

Mary Ann's weak eyes brim with earnest tears. "Oh, sir, a Miz Wilson."

"Well?"

"She has such a sourful hist'ry—"

"So have they all had. Of course you sent her away with provisions for the coming year?"

"A couple of boiled pullits, sir."

"What, no ham?"

"A nice piece off the lean end. Two or three pound."

"And cheese?—the Stilton, that's been in good port wine—?"

"Mebbe half, sir."

"Half only! Scrimping Mary Ann!—Anyway, you must be as honest as they come. But tell me now, did you not give her something to protect my victuals from the dust of the road? One of the old cotton napkins, perhaps?"

"No, sir. One of the nice new linen ones with your gret-gret-graman's flemmy-lace workit to the borders by ol' Miz Sparrow at fearsome cost."

"But damn it *why,* woman?"

"Oh, if you hed a ben here—her heart is then broke—"

"I assure you I'd have torn it right away from the confidence hag, and her heart with it if necessary. She's gone off with a small fortune in *point d'Angleterre.* I'll have to get the deputy on her trail first thing in the morning. But just what did you suppose *I* was going to do with six Dresden settings and five napkins?"

"Set down five people, sir—four lack you, which is to say—or mebbe a couple could share. They ain't prim eaters hereabouts. I rue me to get out the deppety but heigh ho, it hed to be—"

"Had to be! I ask you why, woman? Why heigh ho had it to be?"

"Becuz she were so *romantic,* sir—so much hard trouble and deathless love and the moilin's and 'ventures of her long born day. I just couldn' insolt her with one a the ol' cottins, not but what they do wal fur such as you and I. But not fur a Miz Wilson, sir. Don't you know the way some people are—how they come at the heart and a body not perpared fur it, or mebbe allus waitin' fur it—like es they was the livid picter of all our dreams of the prout knights and leddies of yore, doin' all the noble and curragest perseedings and tekken all the consewences we mought be up to if we just weren't we, mollicoddles fit to mek a stron' hog ratch? Sure you met a couple on yur hithers-and-yonnin's, sir. I fount my beauties right there at the kitchen

doorpiece. They they are the sweet a morning' and salt a the earth to my scarit and feckle hours. I mought say es they live em out full fur me, and welcome with em, say I. Go at it, my polecat American beauties!—say I. —So it had t'be, as I was telling. She just weren't one a yur ol'-cottin leddies and desirt we would to be desarvin' a her. In further pursoonce a which I gifted her with eight a yur good shee-roots. She smokes."

"Smokes?" murmurs the Admirer.

"Like a wet bear with the fever. Spats, too. Wisht I ivver could."

"Mary Ann—!"

"No worry, sir, I wouldn' durst. My eyes is thet near es I'd be all in the Dresdins and five people settin' down fur soap—!

"Believe me, six."

"Ah, poor cripple deppety."

"He's not crippled that I know of." But the sharp annoyance in his face has lost considerable edge. Perturbation muddled in with curiosity and a sense of divine offices are causing him to stare with barely suppressed furore at the weak-eyed young woman, who sees nothing of it. With an effort he composes himself and says guardedly, huskily, "Tell me—are you as perfectly simple and earnest as you appear—?"

"And hones', sir. Perfeckly simple and hones'ly earnes'— to the pint of ridickleness. You mought say es I'm horiginal fur it. Sui generis. My Pa tried beatin' it out a me—"

"Well, go on then."

"On out the door, sir?—nekked into the world who can't see to there? Fur the sake a some flemmy-lace, I who boil yur supper so nice and vanorate the Dresdins and fend folks off a distarbin' you, not thet yur popalar but the could 'r three all tell in a year's Sundays—?"

"You don't know how ridiculous you *are,* woman. I'm trying to say it would amuse me to hear more of your Mrs. Wilson—"

"Oh, you are all condesansion, Mr. Admirer! You are the sweet a mornin' and salt a the earth—!"

Feeling suddenly faint: "In God's name, let me hear—"

"Wal, sir, there's not thet much to tell—" "Mary Ann—"

"She come out a the east, I do mind me—"

"FANTASTIC!"

"Ain't it, sir?" says Mary Ann in evident pleasure at her little coup. "Conneckit 'twas, mos' notional—"

"She's a liar!"

"Now I don't argy the case there, sir. She *were* es deep es a clem respactin' her horigins and hidentities. Fur all I knowd from her shifty way it could a ben China—"

"Never mind that," says the Admirer in haste, perhaps prefiguring drudges and Chinese census rolls. "What else."

"And she had a scanderlous love which the death a who broke her eagle heart, and so she wanders the earth seekin' peace and furgitfulness, scornt a men but unbowit to the varmints. Oh, sir, you ought to a ben here. She was *inconsowlable,* the picter a grief on the moniment, and when she ruz up to leave she sowed such a sigh, sayin' wal, she was off to parts unknowd—"

"Parts unknown. Good. What else—"

II

And so forth.

Now, omitting, the one dim quotation, I believe this version links up some fairly incoherent facts as echoed throughout the memoirs. I also believe a hybrid mold gives point to their shuffling emphases. The Admirer, being a novice at his work, found himself with more traits and "perseedings" then he saw how to synthesize and in despair pasted a random few of them together, spending the rest of his life trying to paste on the sense.

Allowed literally, the thing simply self-destructs. We are offered a pair of excessively naive and unselfconscious lesbians who were excessively evasive about themselves if indeed they were not sinister impostures; a refined Victorian gentleman who frequented their rough company in a precarious cabin with half the support brickwork gouged out for colors; a party of friends among whom next to no words were ever exchanged (or one of whom screeched the identical ten words day in and day out until nothing else survived in memory); notorious figures concerning whom "local legends and recollections ... still lingered" as late as 1894 (N.F. Karlins, *op cit),* who were resident for many years on a tract of good farm land in a New York county, yet who somehow never showed up in the census or any other official record of existence; etc. etc. etc. Agatha Christie would not have allowed it.

This much said, and Agatha Christie notwithstanding, I will now propose that the memoirs of the Admirer of Art have essentially to be true. There had to have been a Mary Ann Willson and her Miss Brundage—or women affecting those names—and more or less as describes. Once one sits back and yields to it, in defiance of every instinct of common sense and/or textual analysis, the very inconsistencies begin to strike one as persuasive. There are two reasons for this. First, no small-time romancer, however green in the job, would be likely to go quite so wrong with materials of his own choosing; his fault would tend rather towards some familiar stereotype with quotations, many more of them, to match. Second, we have the watercolors to prove that Mary Ann Willson was an absurd, inconsistent and altogether unaccountable artist, perhaps *the* American artist of that long ago dream of a new social and cultural order, which in her great simplicity she appears to have gone out and lived.

The decisive evidence for this reading of it is a bracketed aside, almost an afterthought, in the letter with the Stone Gal-

lery portfolio. More improbable than all improbabilities of circumstance[1] is that the prosy Admirer should have invented: ". . . their unqualified belief that these 'picters' were very beautiful (and original) . . ." *And original.* It takes the breath away when one goes to think about it. A Mary Ann Willson, with the natural talent and acquired skills of Miss Brundage's plough horse, a clod of clods, opening shop in the wilds not only as an artist but an *original* artist! To conceive the hubris of that! I tell you the Admirer could not have made it up. Now, it seems doubtful that she meant to fool the man, cultivated as she must have thought him, on the score of her imagery. He would have been as likely as herself to have come across the Tiebout prints and various other illustrations which she took as models. Furthermore, the adjacent dry aside, "(they certainly were)," makes clear this was not his sense of it either. And since some of them

[1]Circumstances were not so improbable after all. A caveat from Maria Naylor, whose talent for research would have given the Admirer screaming meemies, makes the following points: " . . . In the city directories [of the period] only widow ladies with no male dependents over 16 could be counted the heads of households. Spinster ladies were *not* considered as such, even if they owned the house and paid the bills and gave the orders. The census taker might just have lumped them into the household of the nearest farmer (in the free females over 16 category) and have done. Maybe he didn't believe in counting shaped houses. . . . Anyway, it was nothing to miss one or two censuses. I have tracked people over several decades, and found that they disappear from a couple of censuses, then show up again, still living in the same place. . . . Now the tax rolls. . . . Most of the land up the Hudson valley was held by large landlords; they then 'sold' it to smaller farmers in varying amounts, but the title to the lands never passed. The new 'owners' then had to pay an annual rent based on the amount of their holdings or the value of their crops. . . . Say the patroon sells a few acres to MAW and Miss B: he does not give them title, still pays the taxes himself, and appears on the state's books as the land's owner. In return they pay him a percentage of their annual produce, in MAW's case several dozen watercolors, which he regards with superstitious horror, but takes anyway, because that is what patrooning is all about. The ladies could also simply have sharecropped."

certainly are, as I shall get around to demonstrating, the things seems inarguable: she was both conscious of what she was doing, and of doing it in no way previously known to her.[2]

Originality. It is a fairly recent idea in Western culture that works of art ought to be original, that is to say, radically different from their predecessors, or strictly, more like the artist than like the art. There were periodic "renewals," but always within the framework of a responsible meliorism, a belief in the evolving professional cause of art history. And in fact the institutions of the high culture were provided with a number of blow-valves to take down such pressures. For the big, restive talent there was the release of elaboration or simplification; heroic distension, or intimate scaling down (subdivision: sublime content or genre); a choice of emphasis, or de-emphasis (though not of discard); and ever and always the competition of sheer prowess within the medium. But originality on the terms of late Monet or Cézanne or Rodin, disruptive originality, total redirection artist to artist, was never an issue. From the Renaissance the community of taste was grounded in certain primary formal assumptions. Art went onward in the service of a tradition that

[2]As N.F. Karlins notes in the conclusion to her monograph: "There are many questions still to be answered about the origins of an influences on Mary Ann Willson's works ..." A suggestive model can be found in Chapter 13 of Dickens's *Martin Chuzzlewit*, during a scene at a roadside tavern between London and Salisbury: "He pushed away his empty plate and with a second mug upon the hearth before him, looked thoughtfully at the fire until his eyes ached. Then he looked at the highly coloured Scripture pieces on the walls, in little black frames like common shaving-glasses, and saw how the Wise Men (with a strong family likeness among them) worshipped in a pink manger and how the Prodigal Son came home in red rags to a purple father, and already feasted his imagination on a sea-green calf." If, as is not too obscurely hinted in De Lisser's book, England was her place of origin, her arbitrary high color and schematized faces may have been a provincial tradition there. Her originality on and of this soil is not lessened, however, as will be shown.

kept these abiding, though increasingly as hearsay, as lore one was endowed with simply by being a member of the tradition. One mounted the shoulders of the preceding generation (it was a cherished metaphor) as they had mounted the shoulders of their fathers, *ad infinitum* from the giants and in ever remoter perspective to them, until around the middle of the nineteenth century the affective virtue in those primary formal values—the fundament, the solid "art of museums" as Cézanne referred to it—has all but passed from the high culture consciousness, while continuing to impose techniques and strategies by then meaningless.

But at the beginning of that century it was not a perceptible concern with artists, and least of all with artists in the new republic. Gilbert Stuart devised a fleet, loose, almost late-Manetesque touch for his portraits, restoring vivacity to the oil medium if not to his art. Raphaelle Peale took to doing equivocal still-lifes, so small and dainty in content (in an age of important content, which certified the important picture) that they seem hardly the work of his father's son; yet some of them are so intensely saturated—charged edge to edge—they are difficult to get a focus on, *qua* still-life in the "Philadelphia" mode, much as with certain of our interdisciplinary textiles: there does seem to be some plaintive word here on moribund standards.

That was about the extent of our uneasiness, however, And if it was not then a worry with the innovative high culture, much less could it have made a stir in the conservative low one, that indefinite layer of amateurs and naifs and provincial craftsmen. As I have theorized, the dereliction of the culture itself drove out the remarkable single works in our folk idiom, but few of them, it seems safe to add, were launched in a pursuit of originality. The special accomplishment of Phillips's "Harriet Leavens" lay rather in the recovery of sound formal values for himself than in the establishing of new guidelines for the art of portraiture. There is nothing in it to startle or instruct the eye

but a mysterious old excellence, operative as much below the surface as on it, in the artist's entire momentary grasp of his potential. Of course it was novel enough for his age and talents, but it was not consciously original work (as distinct, I hope is understood, from mere device and mannerism such as Stuart's brushing, or the temperamental restlessness of a Washington Allston). It was consciously weighted work, a unique provincial counterpart to that art of museums. The arrogance was just not in the man or his fellows to monkey with the basics of traditional practice.

In the context of this profound conservatism of an ethos, a Mary Ann Willson active 1810–1825 had to be something of a social as well as cultural oddity. Doubtless there were stranded frontier women, widowed or orphaned, who out of necessity joined together to build their own homes and work their own land. Doubtless also some of these developed "romantic attachments" which would have endured as long as their frontier environment, with its sparseness of available men and want of community moral pressures; and the abnormality and physical hardship of their lives would have been all-devouring. Then there were quite other women in snug but intellectually impoverished conditions, who, moored to the routine of their lives, had mind left over to work an inward terrain, to brood their wakefulness into patterns of great formal density and power—as abnormal with respect to caste and custom as those Amazons at the frontier, only unblocking different energies, the art as against the life. But for a pair of young women to head on purpose into the bush, there to clear the ground and with their own hands "form" their own dwelling space, sow, reap and butcher their own food, maintain for many years an unabashedly lesbian household among the settled families, and crowning all, propose their own new art to correspond—to make everything original and strange for themselves—art *and* life—a civilization for two—well, I can't believe there was a surplus of them.

To be sure, mad women might have done it, or self-deluded or fugitive women, but Mary Ann Willson was not mad—or in all probability Miss Brundage then—and she was far from being deluded about her powers. (Conceivably they were fugitives but I prefer not to think so.) She had to have been one of the brainiest women on the eastern seaboard, and in aesthetic intuition by all odds the most sophisticated. I am not unmindful here of our quilters; but perhaps not until Emily Dickinson can we follow another such keen, eccentric intelligence in something like sustained performance.[3]

All the same it is no easy one to follow. Unlike Dickinson's, it was intelligence almost exclusively in an abstract mode, analytic rather than metaphoric, and with no sensuous gift to ease along its discourse. Of our provincial artists with a body of work to their name, hers surely is the most frustrating to get on terms with—relax, that is to say, in the conviction of its perfect seriousness. It is a frequent snag with other ambitious pieces, as indicated in the account of "Sunburst," but in Willson's output the terms are exceptionally trying. She had no painterly talent, none, and none of the natural consistency of style this carries with it. Worse, she couldn't improve. Though the chronology of her compositions is uncertain, and with patently unequal intervals between them, put them together in whatever order you choose there is just no development of the manual skills. Practice did nothing for her; she was a sloven without peer in her medium. Moreover, from sheet to sheet the fiber of thought is dishearteningly variable, from true formal complexity to the childish centering of an image and filling out with wallpaper patterns. And finally, and inexcusably, there was her impatience

[3]If one were impulsive, one might see in the Admirer of Art a rural type of Dickinson's memoirist, Thomas Higginson. Their responses are oddly parallel—dogs with ginger.

to slop an idea down, leaving it often half-articulated and the viewer in wild doubts as to the exact degree of awareness.

To such visual handicaps there must be added our Western sexual bias. At peak effort, in the more elaborate productions based on prints and illustrations, Willson's mind is as aesthetically bold and "masculine" (not to plumb the concept) as any of her era, putting her in double-jeopardy with the establishment of having been not only an unusually awkward folk artist, but a woman folk artist, a would-be fancy-worker. I think it fair to speculate that if a man were known to have done these watercolors ca. 1810–1825 their credibility as serious work—work in a serious experimental vein—would by now have earned them attention well outside the refuge; and Jean Lipman, among the first to see and announce their merits, would not be humbled into perplexing the cause, and their merits, by appeal to 20th-century relevance.

In a footnote to his 1939 essay, "The Avant-garde and Kitsch," Clement Greenberg yawns, "It will be objected . . . that a good deal of folk art is on a high level. Yes, it is—but folk art is not Athene, and it's Athene whom we want: formal culture with its infinity of aspects, its luxuriance, its large comprehension." American folk art, as he implies, has none of this. It is not Athene in his sense of the goddess (though a dictionary entry lists women's crafts as under her aegis); it is restricted in range, optically crabbed—often bare as bones—, parochial in outlook: art in its rudiments. Much of this typifying quality is obscured by linking Willson, as Mrs. Lipman does, to "advanced 20th-century painting" (of apparently whatever decade or school), "action-painterly brushstrokes," a "Picasso version of a Velasquez," and the like. It doesn't serve, in fact comes close to Kenneth Ames's doctrine of similarities, which nicely simplifies the classification of objects while losing the object.

Of course, Mrs. Lipman and other American folk art fanciers of her discernment are in a bind. They cannot seem to

get across to the establishment. That is too bad, but a recourse to 20th-century styles is diminishing to the exploits of Mary Ann Willson, and in the end can only disappoint the viewer prepared for some quaint and amusing modernisms. What could she possibly have in common with artists of our age and their enormous skills and art-historical consciousness (Greenberg's "large comprehension")? Surely not the roughness of their facture or their primitivizing, strategies for them but for her the flounderings of a meager gift. Surely not their rarefied and articulate programs (action painting went at something more than messy exuberance), for she clearly had no program, she was discovering art for herself, not *an* art in *a* style: she could not more have altered her art under the stimulus of example than she could have developed through practice into a Mme. Vigee-Lebrun. And surely not their mocking laughter or their despair, for few artists can have been more passionately and innocently convinced of the one enduring art and the beauty to be found in its raw processes.

True, she did share two quasi-aesthetic liabilities with the vanguard of their century. She lived in a time of "cultural crisis," and (as a consequence) she would be original. But since crisis has been the normal experience in our culture from the nation's beginnings, instigating our rare haunted monuments of world quality, it is too broad a frame for the purpose.

Express originality is another matter in a provincial barely over the 1800s divide. Yet even here relevance is misleading, for the thing was one and the same with Willson herself, her fact and value, and has no correlative at either the fine *or* the folk level. I know I have labored the point but it is essential to bear in mind if we are to get at the drift of our mutants. She was engaged in a radical new enterprise, half art, half self-crystallization—self-weightedness in an unstructured society—and which I believe tells in the almost cussed rough-cast of her performance, and in much other formally integrated but technically

careless work in the American folk idiom. The need was for principles, some lost old-world sense of immanent structuring whose content was incidental to its ballast. The *sensuous* image—as against the weight and coherence of the image—was therefore seldom fully realized, rather was left to impend in a kind of do-it-yourself overlay between object and spectator. It was finished off in the head, exploded *there* into "luxuriance" and ideal beauty, or the recovered sense of it, and is to be finished off in yours and mine. But the crucial work has been isolated and done for us.

In Willson's case the gulf between sensibility and execution is absurd without such an inference. She had a very cultivated eye for pictorial logic, and if her hand insistently disserved her it can only have been by reason of a double or reflexive process underway, an inward cultivation for which the work in hand was a testing ground. The business is otherwise impenetrable. That so subtle and knowing an artist should have developed no command at all of her medium, often satisfied with the roughest ciphering of a complex plastic solution—complex still by early 20th-century standards, though no more "modern" than mid-Renaissance fresco solutions—seems facey even for an American. She had invented the wheel, but who was to know about it?

She was to know about it. (Though a declaration of sorts was made to the Admirer, it clearly did not get enlarged upon.) And as it happens we are in the position to know about it, if we care to. We really should. She is one of our signal phenomena, an autodidact for the ages, and a tonic for those of us who have begun to question the usefulness of formulaic art and its caste of professionals in a dishonored "contract." The recent alternative of post-studio —and by extension post-gallery and post-museum—post-elitist—art, is (or was) no more than a strategy for caste survival. Elitism never was the problem; art is nothing if not the most exacting and thorough of human technics and

therefore the most prohibitive. The manipulation here is in the squaring of elitism with institutions, the caste's desperate politicizing, not to say moralizing, of a purely cultural impasse, namely their narrowed base of reference and influence. Institutions as arbiters of value must surely go. They are stifling us in continuities when we are in need of real disjuncture, an unprofessionalizing and disestablishment of the aesthetic, the dispersion of its rigor and passion into the textures of common thought. (It can be done: I am discussing just such a breakthrough during a time of weakened authority.) Elitism, on the other hand, natural elitism, that pride of first-rateness among us, would seem of all conditions the one to be preserved. There of course can be no serious imaginative work *for* the people; that is neither its function nor its purpose. What is wanted is cocreativity *of* the people, their ascent *to* elitism, at the full stretch of their powers, in absolute commitment of those powers to the modes (not necessarily the forms) of that luminous sanity which is art. (Sanity only—goodness will have to be brought about by other means.) What is wanted is a first-rateness achieved voluntarily outside the cadres, quarter-inch by quarter-inch. Then the democratic work can begin, since each man's wheel as *wheel,* though fashioned to his weight and born capacities and potential, must be as perfect and true as any other. This is equality, but it comes of elitism. Dear God, a republic of Mary Ann Willsons—!

III

Enough formally related work has survived to warrant both particular study and general conclusions. We will consider first and at some length "The Holy Family"—evidently lifted from a Bible engraving of the period—chiefly because she con-

descended to take pains with it. It is not the most ambitious of her projects but it is intelligibly structured throughout, which is to say its artifice cannot be marked off to chance or error unless one is predetermined to do so.

The halo of the Christ child is an immediately arresting feature—a free-form extension of the sky from which it is set apart by the filmiest of blue washes, the weightiest of dark reds, and a brown of yet deeper density. It has neither the shape nor color of a halo—being pristine white ground in fact —and is one only by virtue of the peculiar terms of the discourse: not descriptively but operatively a halo. Those terms then are a kind of abstract grammar, every unit a cause as well as effect, every role multiple, every image or fragment of image what it is and in exact spatial context—pictorially coherent—through a system of mutually played-off ambiguities. Definitions here are strictly correlative. The halo, tending to recede through the red overgarment, is secured in place by advancing the donkey's mid-part *in front* of Joseph, moving the boy well forward and with him his emanation. This is further localized by the device of a green lily (as I take it to be), which moves rearward, traverses the white, catching and anchoring fragments of it behind the shoulder, and grounds itself in the red, formally (if unreasonably) thrust back for the purpose: a complex bit of spatial tactics, at once defining and integrating.

The assertive deep blue of the lower tunic, dangerously abstract in contour, is maneuvered into place by similar nondescriptive means. Just at its collision with the white, there is that complication of leaves and petals, buffering and taming it under. A little below, where it starts to push forward, there is the clinch of the boy's elbow, fortified by simple drawing— always effective against flat color areas—, and from this a descent of some light-hued material, logically (by inference of the elbow) to the front. Yet at the base of this seam the blue edge continues

past the light one, and is then brought emphatically forward of it by a white ankle and black shoe, therewith encoding an action in space without having described it.

What we have, of course, is an ingenious two-dimensional transcript of a three-dimensional event by way of ambiguity. It can't be done otherwise, as Willson improbably made out for herself. All illusionistic flattening the bas-relief or simple mural schema is false to pictorial logic. (I will pass over the charge that she quite simply was unequal to illusionism; she assuredly was, almost, one could add, to the medium of paint, but this does not account for her art in its positive aspects. It is not unknown in Western culture for limits to bring on superior compensations.) The threesome—man, boy and halo—function as a single, shallow, intermeshing lattice, yet also function separately in shallow depth. And neither function, please note, is independent of the other or is ever lost. I grant that such formal refinements are nothing new to us; every professional has had them in his bag of tricks for nearly a century. But Willson had no inheritance of the sort. She homemade them, and there remains the freshness and excitement of *that* even in occasional losses of altitude, her clumsy stop-gaps (as for instance the naive squaring of the oval's foot in order somehow to ground the party and establish a frontal plane; or the herb at the lower right, imperative for a middle distance but left unresolved); yes, in the very inadequacies of the facture; for against all the odds she worked up some highly articulate discourse, not perfect but full of the true cold passion.

Chance and error, chance and error!—you go on as you have been going on for fifty years. What, all of it then? That remarkable multi-purpose beast, whose thrusting flank serves to situate the halo, whose head, softened with texture, obligingly recedes to situate Joseph, and whose ear impinges on the remote compound, constraining it to a transverse as well as in-depth figuration? It is parcelled out like a Mississippi hog, every ounce

and organ of it good for something. And dainty-footed Mary, housed in a mantle whose *foremost* edge is darkened, to inhibit space? So much chance and so coherent?

No: nor yet doctrine, a body of unfailing rules of thumb to ensure her a respectable picture each time around. She had no consistent working theory. None of the pictures is faultless and she seldom brought a solution over, even the most efficient of them. On the basis of half a dozen efforts, she appears to have been beset by a driving intellectual curiosity—some procedure of getting an area of the thing right, recognizing it as right, pinpointing (by and large) why it is right, and making bold assumptions of a general nature. If—on speculation, since we want the chronology—a little texturing of a donkey's head could induce that spatial magic, texture was a structural element that might perform all manner of heavy work. Clearly there can be no development in the "style" of such a progress, no stages reached and cultivated and perfected. The ambition is too vaulting; the mind is too impatient for experience of itself.

In "The Prodigal Son in Misery," therefore, she examines for all it is worth the possibilities of non-descriptive texture as definition, its equivalence in function to color, line and conventional tonal values. A good half of this piece of erotica (sorry but it can't go unobserved, to me indicated a nobly clinical approach to the root of the downfall—the bruised slate colors seem especially scientific) is built on flat abstract areas of stippling and dry-brush marks, receding in optically ambiguous but schematically defined planes. Again, as with flat but unbroken areas in "The Holy Family," they perform the double duty which has been a principle of all sophisticated painting of a decorative bent from Piero's "Visit of the Queen of Sheba" murals onward. It is a complex transaction, involving the most delicate orchestration of signifiers, and that it should be intelligibly employed in even a small run of pictures, in different but structurally related essays, is simply not to be fluffed off on error or chance. Raw

instinct? you attempt to negotiate. But this is to suggest nothing. Instinct in creative work is based on some prior degree of "knowledge," or conception; and the surer the instinct, the more intricate and successful its strategies, the profounder the degree of knowledge that may be presumed. Instinct, perhaps, but hardly raw. One doesn't blunder into coherence time and again.

And her working out of suspensions, of a synthesis of illusion and pictorial logic, the one modifying the other into a fully plastic language of tensions experienced as much as seen, is no small thing to have done. It isn't everything—there is a long impassable way to Piero—but it is competence of a high order, and it is essential art, the irreducible structuring, the wheel. Examine for a moment the high-wire perspective act in "The Prodigal Son in Misery." The "artless" abruptnesses of it are almost queasying to the casual eye. Read attentively, however, as one reads the work of her betters of the period, it makes the most limpid and elegant pictorial sense, as for the chief part their skilled illusionism does not. Signifiers are the key, endless clusters and ripples and echoes of qualification. I don't find a self-contained function in the whole fragmented scene. There is no moving back which is not opposed by a simultaneous moving front; on the other hand, there is no opposition whose force is not mediated by its own counter-force, which in turn etc. etc.—a circular set of neutralizings and warpings to establish solid (ambiguous) ground. And it is solid to this day. The spatial field of the right area of the picture, for example—the varieties and coherence of pure formal device in its definition, the real plasticity (no atmospherics) top to bottom and front to back, clear yet ponderable as crystal—remains an impressive bit of workmanship in any context.

Furthermore, in at least one surviving paper she explores the emotive possibilities of her means. I don't say this is progress. But I do submit it is somewhat recherché for a clod off in a corner of Greene County, New York, ca. 1810–1825, to have

Selections from
The Howard Rose / Raymond Saroff
American Folk Art Collection

Rachel Greenwald (Raquel): Portrait of a Woman. 1935, 16 × 19", oil on canvas board.

Micah Williams: Portrait. Circa 1820, 24 × 21″, pastel on paper.

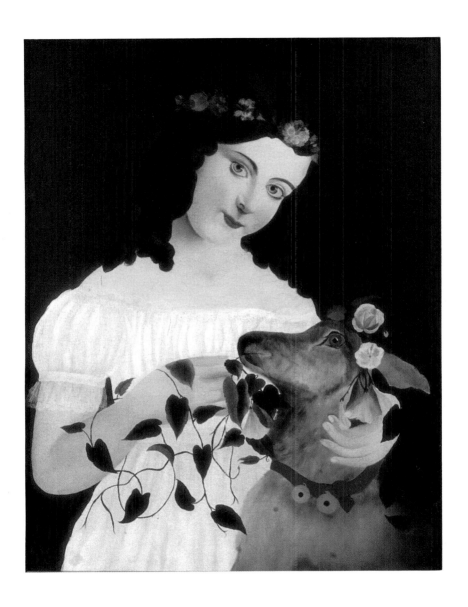

Anonymous: Girl and Faun. Circa 1825, 25 × 19½″, oil on canvas.

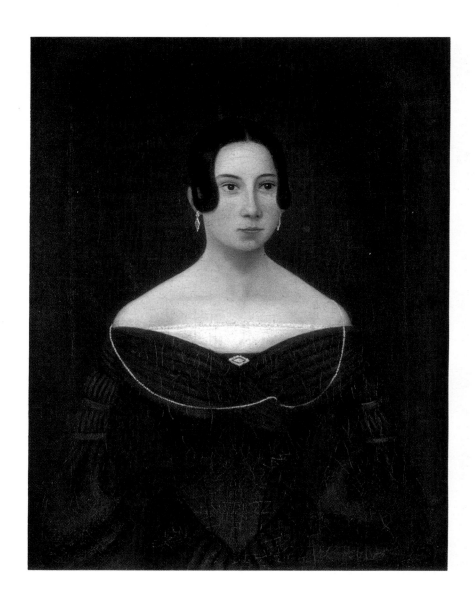

Anonymous: Portrait of a Lady. Circa 1850, 11 × 9″, oil on canvas.

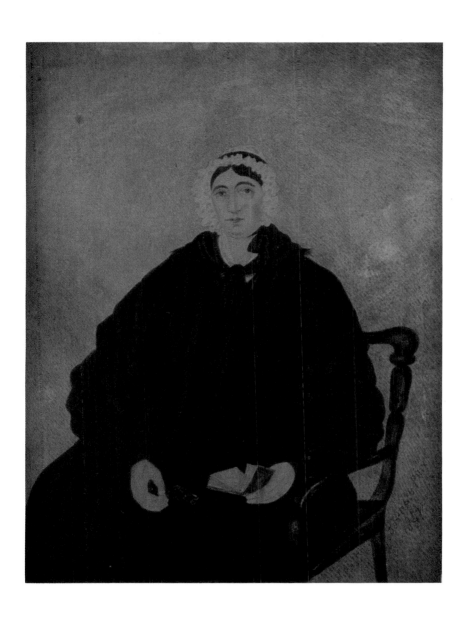

Jan Patt: Portrait. 1847, 12¾ × 10¼″, watercolor

Thomas Chambers: Monastery by the Sea. Circa 1835, 18 × 24″, oil on canvas.

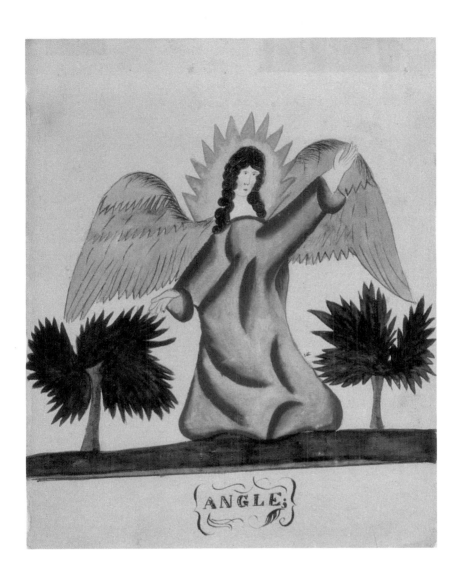

Elizabeth Glaser: "Angle." 19th century, 10½ × 9′, watercolor.

Jacob Maentel: Figure. Early 19th century, 8¼ × 4¼″, watercolor.

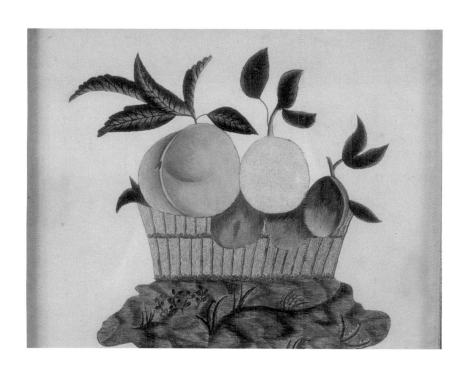

Anonymous: Still-life. 19th century, 9½ × 8½″, watercolor.

Anonymous: Landscape. 19th century, 15½ × 15½″, reverse glass painting.

Robert Salmon: Boston Fire Scene. Circa 1828, 14¼ × 17″, oil on wood panel.

George E. Morgan: Moulton Mill, Randolph, Maine. 1963, 20½ × 16½″, oil on canvas board.

George E. Morgan: Gardiner, Maine. 1963, 16½ × 20½″, 1963, oil on canvas board.

George E. Morgan: Hallowell River. 1963, 12¼ × 16¼″, oil on canvas board.

George E. Morgan: Jewetts Mill. 1962, 18½ × 22½″, oil on canvas board.

George E. Morgan: Hazard Band, Gardiner, Maine. 1962, 12¼ × 16¼″, oil on canvas board.

George E. Morgan: Freshet, Hallowell, Maine. 1963, 16¼ × 12¼″, oil on canvas board.

Mary Ann Willson: The Holy Family. Circa 1810–1825, 13¼ × 11½″, ink and watercolor.

generated what amounts to a microscopic history of art, not only establishing solid ground but attempting to build on it. The aplomb of her is dazzling, and it comes as a nuisance that "The Prodigal Son Reclaimed" should have been one of her frowzier efforts, all smear and terrible drawing, for in conception the scene is a triumph. I will forego analysis and merely call attention to the purgative *blaze,* the stabbings and refractions of blood-red light dimming out all but contours, its source, the exalted old man, literally going to pieces, melting down in big formalized tears.

Enough. At this early move towards an expressionist idiom we can leave Mary Ann Willson with the parting hope that she did not survive Miss Brundage quite so long as to pass into decadence. In any event, she has more than earned her place in the republic of true equals.

Conclusion

In a short envoi to *The De-definition of Art*—"Set out for Clayton!"—the critic Harold Rosenberg pondered our future. The motto is from Kafka's *Amerika* and winds up a recruiting broadside for the Clayton Racetrack for the Nature Theatre of Oklahoma, which opens: "Everyone is welcome! If you want to be an artist, come forward!" As Rosenberg explains, "The Theatre in which everyone is welcome to be an artist is nature as art, a happiness-generating 'man-made environment' ... In the Theatre, everyone not only is an artist but is a work of art. As such, everyone is automatically 'in the right place'; that is to say, in the world museum."

But on this account the future is far from clear. Several of us went to Clayton—perhaps some among us are in Clayton—without ever having coaxed this vision into the democratic agenda. Vision indeed. Rosenberg charts a type of common household practice that from the republic's founding has issued in works (and lives) of the most awesome singularity, no two related yet all curiously of a school, the Oklahoma Nature Theatre, and all exhibits in his world museum. He seems not to have recognized them, though during his long and active career he must have looked hundreds square in the face. True, it is part of their singularity not to announce themselves, as it is part of ours to address the future in guilt-ridden allegories never meant as description and whose harvest is seldom understood, or when understood never quite what was looked for. It is our representative mode of address: the painless sublime; exorbitance to cover the mark-down; a purge of winged radical words out of a full but unready heart. Thus it has been that, paced by Emerson and Theodore Parker, voices have grandly recurred to the dream of

an American aesthetic while continuing to ignore its upstart neophytes. The sentiment of course is in the first order of republican values; the rationale is grounded in our historic mission—as it was left for Kafka to prompt Rosenberg; yet the results will be otherwise surely?—more—something—how does one put it—heroic, downright, forthcoming, spontaneous, expansive, celebratory, gay—American—? Nothing of the sort. Our literalizing of the dream, reducing it to the consequences of some standard American "character" and "mission," has always tainted it as an option to institutional art. Leaving aside those with a vested interest in amateurism, not many are prepared to trade the fastidious cerebral passions of the one for the clownish self-expressiveness of the other. But such indicators as we have do not bear out the scruple. The cream of these works are as fastidious and passionate, as knotted with thought—a new and irregular thought, astringently fragrant—as charged and dense with desire, as anything the culture can show. They are not more than this: they are not Athene in her ripeness; but the deity was once young and plainer and no less herself. In fact, if I may adjust Greenberg's maxim to current problems, it is the young Athene who is wanted, the demonic girl, and not the luxuriance and large comprehension of her professional years. She hasn't been that grey-eyed self in a number of decades.

Meanwhile, for skeptics on the verge of "pluralism," what the future could hold for us is around in some enduringly fraught works from the past. I suggest they look close and weigh the matter.

Problems in Folk Art Criticism

There is small glory to be reaped from a serious appraisal of our folk art. It has become a minor and fusty discipline; the public for it is uncomprehending, the experts are comatose; no recent scholar of name or ability has taken it up for more than the length of a panel viewpoint. Supposing, then, one does nerve to the task and wins through to some fresh perspective, uncovers not roots but rootlessness, not traditions but an improbably fruitful anomie: who of importance would turn a hair, much less trouble to rethink commonplaces that for years have served the establishment perfectly well as judgments? No one of importance would; and therefore no one seeking importance is likely to waste his undivided attention. Yet you must understand that after too many years of such neglect, the continuing vigor and independence of the thing can be annoying. It won't go away, neither will it come inside and be decently installed at the feet of its betters. My quarrel is with a presumption that American folk art will bear any amount of casual derogation. The ensuing brief is therefore directed toward a kind of aesthetico-racial prejudice, as demeaning to the agent as to the victim.

Devaluation

In the *New York Times* for Friday, December 14, 1979, Grace Glueck reviewed Lucas Samaras's show of "reconstructions" at the Pace Gallery, "large-scale abstractions made entirely of wildly patterned fabrics, snipped into squares, patches and big bold strips, and stitched into improbable juxtapositions.... Though their scheme suggests patchwork quilts, they are a far cry from those flat-patterned bedcovers of purely decorative appeal. The Samaras 'reconstructions' ... for all their flamboyant novelty, are designed for the traditional confines of the picture frame, and they are formal creations involved with the spatial illusionism and compositional effects of abstract painting.... Take 'Reconstruction No. 59', to this viewer's eye the most arresting work in a roomful of dazzlers.... It's dominated by a pair of strong diagonals

across the center ... and webbed with several subordinate diagonals which, in repeating lengths of the same fabric, give the picture surface a set of overall motifs."

The most conspicuous affront is the least affective. " ... They are a far cry from those flat-patterned bedcovers of purely decorative appeal." One need only speculate as to the number of prime American "bedcovers" Miss Glueck is likely to have searched out before framing this comment, how closely she looked at them and with what ground-work and predisposition for interpreting what was there. One could also question how deep a study Miss Glueck is likely to have made of the vexed and ever-shifting distinction between the fine and decorative arts that in recent years has embroiled some celebrated scholars (Gombrich, for one); or how much thought Miss Glueck has given to the concept of flatness, since I believe I have never seen a pattern that lay utterly flat upon its surface. Pattern can be manipulated to a greater or lesser degree of flatness, but it takes a deal of adjustment, and compassed over a large area it is a positive not a negative attribute.

With the opening phrase of the next sentence, "The Samaras 'reconstructions' ... for all their flamboyant novelty ... ," comes a subtle depressant. The thrust of course is that the Samaras works are a novelty for December, 1979, in a particular high culture block of 57th Street: no one else around is using a Singer sewing-machine. However, the term is more quietly operative on "reconstructions," whose sense it serves to neutralize, and by logical inference and against all logic on its antithetical "far cry," "those flat-patterned bedcovers of purely decorative appeal"—Samaras's models.

Again, Miss Glueck doesn't argue as much as insinuate that American folk art is *per se* aesthetically vapid. At this level of bias, inferiority is a known rather than an experienced thing. It is futile to expect its thralls to take sophisticated artists—Sheeler, Demuth, Nadelman, Laurent, Marisol, Samaras, King—at their word. Certain old quilts may *appear* to be addressing the mind in formally complex and novel ways but it is quite impossible that they *should,* as they were traditional cottage work fixed within a medium range of expressiveness. Miss Glueck has always known it. Her intimates have always known it. The New York art world has always known it. And you and I are therewith reduced to middling sensations and a faded autumn of the life force, leafing through Cy Nelson's charming *Quilt Calendar.*

Samaras's novelties in fact "are designed for the traditional con-

fines of the picture frame ..." Once again the thrust is explicit: they are traditional fine art for the walls. And once again the buried assumptions do their softening on us. The man excels by virtue not only of innovation but of tradition. His identity here with great easel painters of the past is inescapable. (Even among the American folk art lunatic fringe Harriet Powers is not a Jan Van Eyck.) The frame is evidently what does it.

There is barely assurance left us to recall that as to frames, the notable borders of our choicer quilts—notable for proportion, contrast and formal integration—make them some of the best-framed compositions in Western art practice.... Formal, did we say? Miss Glueck begs to demur. Samaras has the advantage of this too, all of it. In contradistinction to clods, he runs up "formal creations involved with the spatial illusionism and compositional effects of abstract painting."

And with that flies the remainder of *our* illusionism. One clings to the hope that perhaps a redeeming formal sense would be allowed to the adjustments of pattern, however flat. One imagines—erroneously—that formalism, form above content, was in some measure a touchstone for the decorative arts, and therefore if quilts had a purely decorative appeal they would contain vestiges. Never: inferiority is inferiority. Somewhere Alfred North Whitehead has written that civilization matures in proportion as society is asked to think less and less about the commonplaces of its world. Yet on this prescript what may not become a commonplace in time, an unverified and tedious rumor?

Misattribution

Enter now Daniel Robbins, Professor of Art History at a succession of major colleges and universities, in company with Kenneth L. Ames, teaching associate at Winterthur and author of the remarkable credo, "Beyond Necessity: Art in the Folk Tradition." Both of these gentlemen will have cause for surprise at their inclusion here. They offer themselves as friends of the subject whose missions are, respectively, to high-acculturate and to de-aestheticize, and between them —though I do not know if they are acquainted—absorb the folk artist into one or another of the scholarly disciplines. We are here demeaned by a kind of aggressive rancor for all that dares to set up outside the orthodoxies. Professor Robbins's essay, "Folk Sculpture without Folk," appeared

in the catalogue to Folk Sculpture USA at the Brooklyn Museum in 1976; Mr. Ames's (above cited) in the catalogue for a loan exhibition by Winterthur to the Brandywine River Museum in 1977. As far as I am aware they have occasioned no uprising and only a little gruff dismissal.[1]

What has happened, of course, is what happens daily with regard to the slights of Miss Glueck and colleagues. If charges are true we would rather not have to think about them—we are more than comfortable in our limbo; if trumped up we would rather not engage in controversies we may not be able to dispatch with honor, for Robbins and Ames are petrifyingly learned in the source literature. Meanwhile, a lot of roundly stated academic moonshine, strictly premised on forerunners—which is what makes the disciplines so awesomely self-coherent—goes unchallenged into the nervous system, dimming the freshness of our experience and discouraging vigorous new thought. For despite their justifiable views on the retarded state of American folk art studies, what they are counseling is a state more retarded still: the rationalist or conceptual approach.

They come to American folk art with eyes and methodology revealed in the accumulated lore and through the selective glass of the discipline. And as is to be expected they are scathing about the value of outsiderness in their closed constructs, Professor Robbins especially so. "Why then," he writes, "is [American] folk art relatively untouched by both traditional and new scholarship? There are at least two reasons, each complex, and both related to the larger question of the definition of current and past art. The first is the continued attractiveness of the democratic notion that simple and untutored Folk can create work that rivals in value the self-conscious productions of highly trained and sophisticated artists." (The second of these reasons will be unveiled in due course.)

"Value" is the deadly word here, and is pointedly *not* to receive a definition. It is also an equivocal word in the context of Professor Robbins's argument, where there is a good deal made of that which is *done* rather than of that which is done *well* or *surpassingly*. This is something of a contemporary trend in fine art studies on a number of grounds—ideological, sociological, and perhaps the very human one

[1]See Jean Lipman's reference to Ames in her catalogue piece for "American Folk Painters of Three Centuries," page 222.

that surpassing work entails surpassing coverage—and would not draw comment but for the unchanging connotations of value in a changed system of values. You will mark that Robbins does not say "rivals in value the self-conscious productions of naturally gifted and superior artists" but of "highly trained and sophisticated" ones. This intrinsic value charge—lack of intrinsic value—is a set assumption among schoolmen when dealing with the work of American folk artists. One does finally want to know: value relative to what in the world? If to the likes of "Las Meninas," or the "Rape of Europe," or the Isenheim altarpiece, or the Medici tomb "Night," or some still-life of Chardin or Cezanne, there would be no sense in it. If to such as Eakins's little picture of his wife in bathrobe and red stockings, or a pre-English Copley portrait, or Bingham's "The Trapper's Return," or Fitz Hugh Lane's "Normans' Woe," or one of Ryder's marine nightscapes, there would scarcely be more sense in it. Achievement of this class was never part of the "democratic notion"; nor does Professor Robbins apparently have it in mind. He does seem to have in mind exactly the value of being highly trained and sophisticated, that very old-country imprimatur never quite outworn, and which for upwards of a century filled museums with highly trained and sophisticated mediocrities. The terms are not in contradiction. "Highly trained and sophisticated" are value qualifiers and not in themselves a value. They distinguish a kind of value still to be specified. Sir Joshua Reynolds was a highly trained and sophisticated clerk; Titian was a highly trained and sophisticated space-traveller. They were not of the same party.

What we are left with then is value, that which is of value to the peculiar concerns of Professor Robbins's discipline, the nowadays virtually value-free history of fine art, its international bearings, local variations, interlockings and continuities. And no, American folk art is not competitive in that. But neither, in a substantive sense, is "Las Meninas" or the Medici tomb "Night," or indeed any extraordinary reach of mere talent beyond itself.

Nothing of great and mysterious power has value for the new scholarship. It will not connect up. It does not typify or explain or hold in a series. Nothing leads to it, nothing comes from it. It has no relevance to the lives and absorptions of the multitude who are the ongoing locus of history. Yet I think it has: in the close view such outsider work is more revealing of human societies, what they will not dare or

allow but which haunts them always, a need of disrupting climax, some dangerous pitch of capacity, just shy of disaster; more revealing of societies, I think, than all the middleground endeavor that so tamely mirrors the generations of them. Because, lastly, "Las Meninas" was not painted by one Diego Rodriguez de Silva y Velasques *solus*—we were there in multitudes.

This question of value now a little hammered out, we may bring on the next reason for the avoidance of American folk art by establishment sages. "The second is the still growing power of the idea that interested society can stamp its own aesthetic values upon almost any kind of object, that each man who approaches life as an artist will find art and will find it to the extent that he himself is creative. This is an extension, and perhaps a particularly American extension, of a special contribution to modernism that is focused in the work and attitude of Marcel Duchamp: the found object."

Art by this account is what artists and only artists make; and an artist is legitimized by maximum training and sophistication and (by inference from the latter) consciousness of what artists have made, are making, and always will make. *You,* at this butt-end of time, may have longings for a kind of total, near-disastrous commitment not to be assuaged by recent museum and gallery shows, but *you* had just better be quiet about it, come to realize your found-object perversion, and not go about troubling the Bureau of Responsible Artists and their Historians and Explicators. They know what art is, what we require at any given moment in the way of aesthetic nourishment: simply, what is officially made and exhibited at any given moment, just that much and species of it and no more. "Interested society" has become a spoiled fool.

I suppose it is another democratic notion of ours that we have reserved the option to engage in a little supplemental foraging on our own. We are riddled with unnameable hungers. We yearn for that reach beyond ourselves. For what is smugly styled "art" is a process of terrific internal reduction of this or that common experience to thingness and, in the highest art, the fusion of these purified simples to make an integral but indecipherable whole thing, not so much a new subject for thought as a modifier of the very conditions and limits of thought. Art most certainly is not a matter of conventions and skills passed along and progressively puerilized from one eager clerk to the next. Should some untrained hand, under pressure of mind at the

pitch, have laboriously realized one of these dense reductions, and left it rough and mute and by reason of extraordinary integralness somewhat more than ordinarily indecipherable, why, society would have not only to be a fool but an art historian to find it of unequal value with sophisticated clerk work.

There is, however, a more crucial arraignment buried among the remarks leading up to the formal two-part bill of academic reproach.[2] "Since 1938," Robbins writes, "serious historical study has discovered a set of traditions and concerns out of which the artist created for a community for almost every category of art once lumped together as primitive. Only in the realm of folk art has research not yielded a similar pattern. ... Studies such as those of John T. Kirk demonstrate the relationship between high style and country furniture, and research has advanced the precision with which we can date a piece and our ability to pinpoint its regional origin, not only by reference to the sources of its forms in Europe. . . ." *E strano!* Why should American folk art be free from predation when all around has been eaten up with regional origins and European sources and reduced to a process? "What is it that has so *curiously* [my emphasis] retarded the study, though not the appreciation, of American folk art?" he asks, and answers with that two-part bill. But if an organism, alone of its company, comes unscathed through a pestilence, it is likelier due to something queer or novel in its blood than in the circumstances. Could the thing perhaps be that traditional and new scholarship have held aloof not because of the chaos resulting from democratic notions, but because American folk art is or appears from soundings to be what is past conception to serious historical study: *sui generis* a chaos? Is the thing perhaps not so much the irksomeness of making head or tail of the shambles left, as misgivings that the body of American folk art might prove on examination to have had no head or tail? The almost unrelieved inconsequence of the survey to its materials, its message that everything would be found decent and in order if only we would

[2] Actually a third part, but in the nature of an admission, is relegated to the notes, and it therefore is here. "One practical, though partial answer [for neglect] is found in the reluctance of most scholarly institutions to recognize the aesthetic quality of folk art, and encourage it as a valid subject for scholars." The logic is circular, since presumably the aesthetic attitudes of a scholarly institution are shaped by its generations of scholars. The statement in effect reads: *scholars* are reluctant etc.

go by the rules of history rather than the evidence of the eyes, indicate that such misgivings have been the real kibosh.

Because Professor Robbins at no time confronts the singularity of his subject, the mutant *cloddus horribilis*. (Its "friends" seldom do.) He talks urbanely about what he knows. He piles up scraps of scholastic theory on less or more related topics, constructs an alter-image of less or more resemblance, and puts head and tail to that. Accordingly we begin with a column-long seminar on Henri Rousseau. This though a little earlier we are made to understand how Robert Goldwater, in *Primitivism in Modern Painting* (1938), "brought intellectual order to an area that previously could only be described as chaotic. . . . Goldwater's study cut across the blur by carving out intellectual and historical categories that describe distinct arts produced in different contexts. . . ." In other words, Goldwater presumably sorted out the primitive from the exotic, both of these from the folk, and all of them from the "popular." Nonetheless: "A brief discussion of Rousseau's place in the rise of primitivism gives some indication of the errors to which folk art enthusiasts have long been prone."

Here follows a scissors-and-paste job on the Douanier, in which it is explained that his artistic ideals derived in fact from Bougereau, and that cognoscenti of the time accepted this and enjoyed his work in proportion as he fell short, "satirized" them "by the slight jolt between the almost polished technique and the ideals . . ." "Rousseau is a genuinely interesting artist within strict limitations because, although his ambitions were high, the content of his art is considerably less high than he thought." Further along: "We encounter here another constant and deeply moving characteristic of the naive artist: Rousseau's belief in the importance of painting in his own life, his 'unconscious acceptance' of the value of art in the life of the community. This is the only unselfconscious aspect of Rousseau's work. Everything else—the ideals and the means—were derived from the conventions of high art." Further along: "His work can only be understood and appreciated in its double relationship to the high art of his time that he himself took as an example and those artists who, departing from it, chose him as a kind of mascot."

By now the reader of an essay purportedly on American folk art may be excused for wondering if Professor Robbins had sent over the wrong pages, until: "His continued importance for discussing the

larger question of folk art is the astonishing persistence of the notion that he (or Clarence Schmidt or Simon Rodia or Edgar Tolson) was the living synthesis of an anonymous multitude of humble artisans, from sign and house painters to the decorators of travelling shows; that he (and they) represents the vision of the common people; that through him, *mysteriously without the intervention of guides from the instructed classes* [my emphasis], the common people have found plastic and permanent form." Professor Robbins creates a mystery and goes on to solve it for us. He does this by taking as role model a European "popular" painter with atypical credentials even among "popular" painters, and with him quashes one of the enduring nuisances (to scholars) of American folk art: the sources of its formal invention. To be sure, he has a particular understanding of formal invention—that which alone places an artist within a course of development. At least he does for the purposes of this essay. Formal invention here signifies imagery, or occasionally just pose.

We are not often reviewed by the gentry and on those occasions when we are have surely a right to look to profit from their cultivation. Their neutral vantage and perfected tools, their experience of the world and those habits of candor and scrupulosity instilled by their high station, seem just what is wanted to prepare ground for an imaginative leap. Yet is is always the same when they come. We have centrally deployed our best wares, grouped them for study in full illumination, and they dart like streaks for the shadowy corners. So much said, we do remain with pitiful merchandise to acocunt for in the shadowy corners. On the other hand, it is in the corners; and it seems hard to be diagnosed by what was never at issue.

Consider. In full sight and good light we have hung a huge sheet-iron curlew weathervane, ca. 1870, fit to have told the wind for any mosque in Byzantium; beneath it we have placed the little carving of Henry Ward Beecher, ca. 1850–60, with its swirl of garment stopped between two blind heaven-facing planes, hushed and tense as an angel of Barlach's, and more formally inventive; to one side, the painted wood construciton of Miss Liberty, ca. 1910, all her fierce angles—none the same—exultant and speaking; to the other side, the figure of a kneeling sailor, early 19th century, carved and painted to mount a ship's chart-board, with its magical permutations of an incised curvilinear base motif upwards through flexed feet and knees to flexed

hands and fingers—a suave conversion of pattern into form one would have thought impossible to bring off with so bare a style; hard by, James Lombard's small rooster vane, late 19th century, sawed from a pine slab and painted ochre to simulate "leaf," a work that for mastery of curve organization, and each curve imperfect and imperfect in a different way, and some positive and some negative curves, is a simple wonder.

Does Professor Robbins take on any of these banner pieces, or choose among a hundred others equally or nearly as fine, which figure regularly in books and catalogues of the subject—the canonical work around which the reputation, the "astonishing notion" of American folk sculpture has crystallized—and point out to us their European sources and/or relationships with high art of the period? He does not. He disposes of them by stealth. He traps them in a formula which he proves with the assistance of commercial horse-and-sulky vanes. Nowhere is the abiding paradox—which is not that otherwise sane Americans continue to believe such miracles are possible, but that such miracles were in fact performed—nowhere is this paradox touched upon.

There never was a notion or paradox concerning the kind of Americana stuff he solves. No responsible American folk art authority has gainsaid its derivative habits much less the modesty of its gifts, aims and accomplishments. Indeed, it is cherished *for* its shortcomings, not in spite of them. So far from being the whole of the matter, American folk art and Americana are distinct arts: or rather but one of them has pretentions to being an art at all. Americana, I suppose, belongs under the activity or discipline of what is called "material culture." It has fanciers, and I by no means begrudge its right to a hearing; I simply want to carve out its intellectual category and contain it there.

If American folk art is to be laid to rest as an integral genre by appeal to "the complex process of cultural diffusion that joins the isolated, untaught, or self-taught artist to the images and ideas of aesthetic innovators," then logically they who innovate must make their images and ideas out of original substance. This contrast, of creation/re-creation, is a pointed disparagement in the essay. But where is the contrast if the innovators in their turn make images and ideas out of other images and ideas? Manipulative logic over too many pages and with too little respect for its subject exacts a price. No art scholar in the light of day would allow his readers to infer that innovating art since the

Renaissance was about its effigies, or is even partially to be weighed against the less or more originality of them.[3]

Professor Robbins supposes that American folk art, after the fashion of folk art everywhere, germinated in response to a need of an unproblematic art for all the people; that in consequence American folk art is little more than a simplified, representational (and borrowed) visual imagery; that a visual image and a visual idea are at root one and the same thing. Maneuvering these premises with great flair, he surfaces at length with his crowning vision: Pop Art as the ultimate folk art. He began with Pop Art as destination and from the outset focused the evidence to lead there. He adduces Lichtenstein, Johns, Warhol and Dine, but—leaving aside the incongruity of aesthetic among them, similar to his offhand grouping of Rodia, Schmidt and Tolson—what in fact he is talking about are the third-level Pop-ularizers, the Indianas and Wesselmans. He writes: "Some artists—high artists like Roy Lichtenstein—have grasped the possibility that they could be artists for all the people." On sober reflection, can he believe that Roy Lichtenstein, not to mention Johns or Dine, has been composing swank

[3]As long ago as 1950, in a since much referred to symposium in *Antiques* magazine, "What is American Folk Art?" (illustrated, you may be sure, chiefly with Americana), the problem was addressed from on high by James Thomas Flexner. "Once it was generally believed that our simple artists, uninfluenced by the dominant fine arts conceptions of their periods, worked in an independent manner that was a unique product of the American soil. However, writers who are determined to adhere to this premise now find themselves reduced to the lame expedient of arguing that when a primitive painter copied the work of an academic painter, he transmuted it into something altogether different." The evasion here, of course, is the cant "lame expedient." The point is, did he or did he not transmute it? The unresolved, the lame expedient comes home to Mr. Flexner. A dependent point: if two or three or fifty did not, does it follow that most or all did not? (It happens that most did not, but this is *not* a point with American folk art, which makes no claims to the normative.) Another: who is to be the more prized, he who innovates or, where a process is shared, he who transmutes innovation into the elemental gold? Like high training and sophistication, innovation—the province of "fine arts conceptions"—is not value but a qualifier of value. As a term it classifies but does not appraise. Cézanne was an innovator, Gluck was an innovator, Wordsworth was an innovator; but so were Pre-Raphaelites, Meyerbeer and John Lyly innovators. Grünewald, Bach and Shakespeare transmuted merely. And a final point: which, by aesthetic law, are the "primary" sources, and which are "secondary," emulative, and therefore out of bounds to the transmuting consciousness, and since when and on what authority? Who will say how alchemical gold is to be arrived at, as though it were a base moral element? Who indeed but an American scholar.

glosses on abstract expressionism in an effort to share the Norman Rockwell and Wyeth audience?

Improbable as it sounds, he can and does.[4] " . . . This is the deliberate result of the often wished for, but seldom achieved, juncture of high art and popular interest." Popular interest: a few thousand upper-middle-class folks in a dozen high-culture or would-be high-culture centers. We note, *obiter dictum,* that whereas in American folk art he entirely ignores the triumphs, which are of the essence, in Pop Art he has found it expedient to reverse the strategy, and equally to ignore the essence.

For too many years the scholastic establishment—and "Folk Sculpture without Folk" is a fair sampling of their arrogance—have ridden hobby-horse at the margins of the field, until a unique American enterprise, manifest to the eye, has lost all intellecutal bearings for a public disposed to credit its scholars, and without which bearings there can be no useful visibility. It is time they either abandon us or do some honest looking at what we claim to have found.

Fundamentalism

Though equally dismissive, Kenneth Ames's "Beyond Necessity: Art in the Folk Tradition" mounts its attack from another quarter. Professor Robbins argues that it is impossible for unskilled and unsophisticated people to create works of genuine aesthetic value, Mr. Ames that such value, if or where achieved—he tries to avoid a decision—has no bearing on the subject. Worse, it is a positive hindrance to undestanding the role of artifacts in human affairs. And that objective role, as distinct from that subjective value, is nowadays the proper study of man.

We are entering the strange new world of Material Culture. It is not my world (as in effect I share one with Professor Robbins) and I approach with some wariness. The boldness of the thing, its broad

[4] "Lichtenstein most valiantly and wittily created the famous original cover print of Robert Kennedy for *Time*." This is the single bit of evidence offered, and seems rather like impeaching a man for ogling the whores. Yet even that seems not so impertinent as fulsomely praising him for it. Valiant indeed. Perhaps Professor Robbins makes no distinction between "deliberately" creating a market and "deliberately" creating an art form.

simple corrective for what indubitably ails us, tantalizes even as it alarms. But its laws are hard to accommodate. The principal trouble is with a kind of discourse, well within the sphere of culture studies, where aesthetics—quality—high, low or indifferent—has no part in the summing up. It abashes one to hear that in a group of related artifacts none is of superior worth or interest to the others, that all which humanity makes or has made, from Rheims cathedral to a paperclip, is indicative of its genius and so equal in the minds of responsible judges. Jean Lipman has crossly referred to what she calls the *retardataire* tendencies of Ames and his confederates. I believe she is wrong. I suspect they are the stuff of the future. This is not the old running skirmish between archaeologists and aestheticians, each defending a staked-out discipline, but a first move towards universal archaeologizing.

"In a suggestive little volume, 'The Shape of Time,'" writes Ames, "George Kubler argues in favor of expanding the concept of art to include all man-made objects. This is doubly salubrious. First, it puts all the artifactual world on an equal footing by abolishing ranks. Secondly, it does away with the problem of having to distinguish art from non-art, thus providing a welcome release from a persistent compulsion that has diverted energies from more productive investigations ... It is time to admit that art is not an eternal truth but a time-linked and socially variable concept, its definition being altered in response to complex patterns of social interaction ... It is intellectually irresponsible to continue to unreflectively confer the honorary degree of art on a small segment of the artifactual world of the past, blithely ignoring most of the artifacts because they do not measure up to an unstated but implicit canon of acceptability."

You stare: is it offered downright—not just in some relative sense? Yes. I mentioned the thing was bold. Of all the fundamentalisms currently putting the fear of God back into liberals, the program of Material Culture looks to me as momentous as any. Liberals will scarcely agree with this. For them the momentous phenomena are to be traced out in some infra-structure more or less according to Marx. There is the serious business of the world—economic and social arrangements—and there are the pleasures and pastimes. Well, I will hazard the view that aesthetic arrangements, of which "art" is a tangible but by no means exhaustive mode, bring as much weight to bear in the serious business of the world, top to bottom of the social order,

as their two shibboleths combined. They negotiate through our ineluctable rage for performance, for what is handsomely done, most successfully articulated and rounded as experience: the purgation for each of us in the highest style or art of experience regardless of content. And this rage for performance, this deep faith in the redemptive value of style, the show of what is done, influencing judgment at every level—distinguishing between civilized and brutish power, the glorious and the oppressive despot, the noble and the ignoble victim—is aesthetics neat. It constitutes an all-preserving government of forms, an art over and against an ethics of taste and choice, and no economic or social revolution is going to make a difference.

Ames understands something of the problem. He quotes James Agee in *Let Us Now Praise Famous Men:* " . . . above all else; in God's name don't think of it (any piece of work) as art. Every fury on earth has been absorbed in time as art, or as religion, or as authority in one form or another. The deadliest blow the enemy of the human soul can strike is to do fury honor."

The position is Tolstoy's and I have come to deem it inarguable; and though it cuts at the root of my position, aesthetic human soul that I am and must remain, if I saw it as the burning issue of Material Culture I would be silent. I would not hypocritically pretend to welcome Material Culture, much less consider revamping myself on its principles. I would watch it pass by, without acknowledgment but without quarrel, towards its all but certain triumph in the new age. Shy of poetic nuclear justice, whose raptures I take it we are willing to forego, we have pushed aesthetic strategies about to their limits, and saving out a few monuments of art we have not done generously by our kind. I am not the person to undervalue these monuments. While mortally thralled to all such closed structures, those vital still-points for the Western mind, I have found it possible to realize back in consciousness that they are not truth, or charity or justness, nor can they be any factor in a genuinely new age, since they are so much the grammar and book of a failed old one.

But if the arguments of Kenneth Ames are representative, this dead-end is by no means the impulse behind Material Culture. The Agee motto proves to be an intimidating but harmless plank. It suggests, or is meant to suggest, profound humanitarian causes too sacred even to punctuate decently, but which the delegations are to understand as charging every word of an otherwise insipid platform. True,

we are offered a bill of evils; and among them, true, the indifference of connoisseurs to the Black stereotype perpetrated by American folk dancing-toys, or a habit of "describing objects as ugly, tacky or kitsch" and thereby "deprecating their makers or users," are symptoms of aesthetic society. Surely there can be no question as to the unfeelingness inherent in taste, but these are idle samplings at a very low reformist temperature.

On the other hand, it is unsettling to find a pronounced absence of taste in those who set up to judge the issue. A cat has every right to look at a queen, but who would care to know its verdict that she looks just like anyone else. This is not doing fury honor *or* dishonor, it is in a different frame of reference entirely, useful only to cats. Ames's honest philistinism, his gingerly forays into evaluation, his perplexity over what the connoisseurs imagine they see when they exalt one artifact above another artifact of roughly the same measurements and period style, serve to render his good cause more embarrassing than persuasive. He has addressed himself to a great contemporary disquiet with seemingly no idea of its scope and bearings. An inborn faith in style over substance, in redemptive organization and execution, in some formality of living without thought for the content of what is being lived—this is not merely the hindrance to a proper study of chairs and tables and dancing-toys he appears to think it is. It structures whole societies and civilizations. Its purgative techniques have time and again defused the rage of sensible men near the limit, reactivating a terror, deeper than rage, of life without forms.

The essential posture of Ames, however, is not that art of this concrete mode is but one of many strategies for being together in the world, as much a tool for the maintenance of its strategy as centralized government or a mode of production, and therefore for the benefit of a languishing civilization it must go; but rather that niggling value judgments are dead weight to a growing body of students with no interest in them—calibrators and systematizers, statisticians, recorders of all the little things and the little spaces between all the little things, and the ratios of all the little spaces between all the little things, and the ratios of significant little groups of all the ratios—and so for the benefit of their pure research it must go.

Ames reacts strongly to the indignities we commonly put on one another in the service of beauty. He has a gift for sudden penetration that can be most beguiling. And there is refreshment in the novel

supportive goods he brings us from the four corners of philistia. The problem lies with vocation. Yet no amount of expertise is going to offset a want of some born aptitude for the work.

To be sure, aesthetic blindness leaves much of the world, including much of the art world, for a person to function in. With prudence one may even finesse shame into a moral or philosophical axiom. He and (presumably) his colleagues have seen fit to challenge a mighty principle of the social order for the narrowest of motives, an unhappiness with their place in the culture order, and by doing so have pretty thoroughly foreclosed the question to serious thought. If they fail to see any quantifiable value difference between a so-called art object and a paperclip, why that is their right, or that is too bad, but it seems hardly grounds for inferring that art objects do not or should not exist. It could be simple incapacity on their part, such as I have for the humblest geometry problems, and over which I fret but do not therefore mount a campaign to exile geometry from the planet. There are individuals born to it who can solve the problems, including six-year-old children. If those who advertise they do see a value difference are so unfeeling as to look down their noses at those who say they do not, and against all Material Culture laws persevere in displaying atypical objects in ahistorical sequence, that again is too bad, but not I think what Ames was really talking about.

Understand, the essay purports to follow a new trend of inquiry in the field of American studies. To judge from the number of congenial scholars quoted or paraphrased it is a burgeoning and resolute trend. These people mean business. They will replace our (admittedly) shopworn values with a program of services based on unadulterated information. "The emphasis on aesthetics combined with the elimination of context as a step in the apotheosis of an object to the status of art severely hinders the historian's attempt to explore the artifact's place in space and time." In other words, not a liberation from furies but a switch from one fury to another, to obsessive context, to plenary data for its own sake.

Three of his five myths—numbers 2, 3, and 4—are operative in much of American folk art writing, which if left as formulations, terse and suggestive, can distract an opponent set on refuting him. Being a Material Culturist he will go on to testify with moot "facts" from as diverse and out of the way sources as possible. With these he will build us irrelevant and incoherent "contexts," and reduce his good cause after all.

APPENDIX: PROBLEMS IN FOLK ART CRITICISM

1. INDIVIDUALITY:

"The folk art propagandist's paean to individuality does not stand up under scrutiny. The easiest and best test is to look at the material on which it is based. The Flowering of American Folk Art [Whitney Musuem, 1974] provides a concise survey of images. Despite the attempt to emphasize the uniqueness of folk art, repetition is more striking than innovation; similarity outweighs diversity. Like all human behavior, the folk artist's approach to the subject and the manipulation of materials are patterned. The variety of surfaces and subjects does not obscure the fact that the designs are products of similar cerebral processes."

Similarity, though useful in demarcating an area or context for judgment, is itself never the judgment. The evidence of look-alikes is customarily the beginning of knowledge, an archaic stage in the perception of some unstudied new field, with the crucial work, the sorting and evaluating, still to be done. It is a rough and ready model of appearances which may or may not be incidental, and outside the objective mode of the physical sciences is scarcely to be relied on for probable truth. A personal opinion of similarity—what strikes one as such—is as indemonstrable and open to question as the opposite claim, and can form the basis for a reverse myth.

2. THE POOR BUT HAPPY ARTISAN:

"Those objects which brought joy and happiness to the users did not necessarily elicit the same emotions from their makers ... Handwork does not necessarily make labor more enjoyable ... Present-day folk art enthusiasts tend to project their enjoyment of current voluntary part-time involvement with some handicraft onto an age when handwork was unavoidable. Their current dabbling in manual crafts today is pleasant partially because it is not routine but an exception."

So much for happiness. Now to impoverishment: "The myth of the poor but happy artisan contains a strong dose of unreality. ... In a forceful and fascinating book, *Urban Blues,* Charles Keil associated this with the moldy fig approach to folklore. *Moldy fig* is the term formerly used by jazzmen to refer to an individual interested only in jazz before World War I ... and is applicable to the context of folk art as well ... The *real* bluesmen, who are analogous to the *real* folk, must meet stringent requirements," among these being old age, obscurity, correct tutelage and an agrarian milieu. "Instead of analyzing the read-

ily accessible remnants of tradition around them, today's moldy figs search the deep south, Appalachia or the Canadian Maritimes for obscure figures who fit as many of these characteristics as possible. The youthful, prominent and successful folk musicians are unacceptable and their music diluted, crude and corrupt ... Most moldy fig folklorists sidestep the issue of material success by concentrating their efforts to find the poor but happy folk in remote rural settings. Were they interested in tradition, per se, they would examine ghettos, ethnic enclaves, and the neighborhoods encircling the urban campuses."

I think this a fair reduction of the argument, and the first thing to be said is that in embryonic idea, omitting development, the initial point is usefully made. If the peculiar exploits of American folk art are to find their bearings, the Gemutlichkeit approach must be jerked around even at the price of a little discourtesy. That the approach has or is claimed to have certain expedient grounds to justify it—the assembling of a large public and the responsible critical interest this would draw—seems no good reason to gentle the thing. An art for everyone is no more an art than an instantly available public is effectually a public.[5] Such a public is an aggregate of random and free-floating units, unassimilable but forever swarming together here or there at the margins of some excitement, eager to be petitioned in. The source of the excitement is immaterial. Having no pressing convictions of their own, they are gnawed with sharp if fugitive hungers for the interests of other people. But be warned: though they encourage with their readiness to look and hear and effusively approbate (by echoing) a judgment, they pose conditions. *Imprimis,* they will not learn. They are inflexible on the point. They are glad to bulk out an audience but there must be no attempt made to deepen their understandings, which are God-given, republican-trained, and as good as another's.

[5]In a piece for the Sunday *New York Times* of Feb. 1, 1981, "The New Collectives—Reaching for a Wider Audience," Grace Glueck described a somewhat comparable maneuver: "'I found the art scene of Manhattan too closed in,' says Stefan Eins, a 39-year-old artist from Austria who has been living in New York since the 1960s. 'I felt it lacked nourishment, and a broad enough audience' ... And so two years ago Mr. Eins took himself to the South Bronx, rented and cleared out a rubble-filled storefront, then opened Fashion Moda, 'a Museum of Science, Art, Technology, Invention and Fantasy.' Presenting a wild mélange of shows by artists, community residents, children, graffiti-makers and other creators, Fashion Moda has been a resounding success with its South Bronx audience, and, despite the disapproval of critics, has attracted the attention of the glossy art world that it left behind in Manhattan."

APPENDIX: PROBLEMS IN FOLK ART CRITICISM

And just then numbers, numbers of anything, were in urgent request. We had to display numbers. Not alone museum people and collectors in doldrums, but prospective corporate sponsors and government funding agencies were counting heads, heads of anything, at the gallery shows and flea-markets, clearly tantalized.

It should therefore surprise no one that the entrepreneurs seized the juncture not to mend but to institutionalize their errors. They have had a success with American folk art, as we measure these things nowadays. It is a thriving concern—sponsored, subsidized, journalized, and borne with in neutral silence by a success-intimidated art world. Its collectors are rich in auctionable goods; its evangelizing among the simple, in the form of seminars, tours, slide shows and workshops, is expertly managed; its exhibitions go all the way to the Orient; its literature is year by year insulating out the questions, there being a point of solemn foolishness beyond which questions die in the questioner's mouth. They won't be heard, or if heard understood.

Nevertheless it is useful that Ames should persist—in idea, as I specify. Because the second thing to be said is that in application—examples, correspondences, argument—the way is all but lost, and with it the premises. I am sorry to have to carp at his rhetorical failings, but I do not want the premises lost. It is an object of some moment with me that they stand inevasively in sight of the American folk art establishment. They must be thought upon and they must have an accounting. If Ames distorts in the root assumptions of myths 2, 3, and 4, he must be rebutted at length. These are serious charges. The establishment, all that complex of writers, dealers, curators, docents, specialists, experts and taste-makers, has in trust some of the few unique emblems of American democracy, as yet undiscovered not to say unsuspected by its proper audience. Should the fault in truth lay with that audience, or with the peculiarities of those emblems, and not with strategies of misrepresentation and self-aggrandizement—I did not mean to challenge Ames in this, only to fill up the picture—the establishment must lose no time in explaining how it is so and has been so during half a century of seasonableness.

In the very heading of the myth he goes astray, affixing "happy" to artisans when as things stand their art alone is (or ought to be) under consideration, that purportedly untroubled, childish, instinctive, wholesome, organic, contented, red-cheeked, bland and sedative art: a nursery for misfits. He is re-surveying ground not for American folk art but for its social studies, which can be of no benefit until the art

itself is measured and situated. Of what importance it is just now if Schimmel the man has been condescended to? For that matter, of what authenticity is the claim? A man's hearsay conduct is open to any number of interpretations. Those who choose to call him picturesque have conceivably read all of Ames's source material and spell the gossip another way, perhaps by the light of its Pennsylvania Dutch ethos; or perhaps are just more tolerant of loners and not so ready to impound them for lacking friends or sleeping in barns. Civil liberties. I suppose a man may die as constitutionally in an almshouse as in a palace, and like it as well. But that his savage, formally elegant carvings, and the frenzied but accomplished painting of their surfaces, are bleared up in some general picturesque, and burbled over and "enjoyed," and passed from hand to hand—this is where condescension has done provably injurious work and this is what needs redressing.

So too with the "realities" of manual labor. Once again Ames has been lured off the text by a somewhat priggish philanthropy. Beyond any doubt a production-line is deadening; and weaving and stitching can be tedious; and itinerant painters met with episodes not delightful; and "present-day folk art enthusiasts tend to project their enjoyment of current voluntary part-time involvement with handicraft onto an age when handwork was unavoidable." Certainly; but what of it? The focus continues to veer from the fate of products to the fate of producers, which is another story—a more momentous one but another one. Inasmuch as his paper is subtitled "Art in the Folk Tradition," and not "The Condition of the Working Class in (New) England in 1844," we must persist in guiding Ames back to what he is (or ought to be) talking about, and that is (or ought to be) the effects of romance on public perception of the art. The conditions of production are only less irrelevant than the artist's state of unhappiness while producing. One may misconceive both realities without serious distortion to the product, which, if it is art, and doubly so if it is American folk art, has little evident relation to circumstance. The artwork, however, is very substantially altered by ignorance of its aesthetic, and discounting the naive collectors it cannot be blamed on creation myths—high art fanciers, as ignorant as any, are not such dupes—but on some compact among entrepreneurs to play down the harsh, crabbed, elitist difficulties.

The moldy fig conceit, "applicable to the context of folk art as well," is a disaster from which nothing can be saved. There is no guiding Ames at this remove from the subject. He tells us the *"real*

bluesmen, who are analogous to *real* folk, must meet stringent requirements" to qualify as such, and that the requirements are, foremost, old age, obscurity, correct tutelage and agrarian locale. Yet not one of them remotely obtains as a criterion for American folk artists, whose ranks are graced equally by seminary girls and young matrons, successful portraitists and ship carvers, Lumppes, Cloddes and Oaffes as untutored as babes, townsmen and vagabonds: anyone, in fact, with a decent ineptitude, one functioning eye and some itch of intellectual passion. If there is a parochialism the American folk art establishment may not be burdened with, it is dogma as to who is qualified to make the art. He who has made it is always qualified.

3. HANDICRAFT:

"Another of the myths making up the web of folk art ideology is the beliefthat the objects which comprise this category have been fabricated by hand and are therefore superior. No machine, no inhuman intruder, no aspect of industrialization which has darkened the world and our hopes and dreams, tempts the creations of the folk. This myth, like the others, has a limited basis in fact ... The problem lies in an over-simplified diagram of cause and effect. [!] The machine and industrialization have been made a scapegoat for concurrent social ills."The tendency to blame machines for complex social problems can be traced back well into the last century. but there are obvious difficulties with the argument. Chief among them is the inescapable fact that much of the amelioration of physical conditions is attributable to the accomplishments of machines and their ability to reduce human labor and the cost of material goods. It is difficult to deny that society has benefited from industrialization. In fact it is doubtful that anyone would take seriously the claim that industrialization is responsible for current social problems ..." Etc. etc. etc.

In fact is it doubtful that anyone would not take seriously the claim. But the social ills or benefits of industrialization are scarcely our current problem, his or mine. Society, I think, had better vacate the premises for the time being. What he ought to be saying is that there has come to be a sort of antiquarian piety, a chasteness, primness and social conservatism in the tending of what was by all odds the most outrageous assault on European norms in the country's record. This piety, he says (or ought to be saying), which is grounded in fears, and longings for security and innocence, has been put in the form of a value judgment on handwork, of which old examples are by and large superior.

From the above motif—one of his triumphs—Ames again goes on to ruin himself in the development. "Why people now prefer handmade objects is a complex matter." We are offered a scholarly-arch rundown on the craft movement in England during the last century. "In those [industrially booming] years the virtue of handwork was eloquently pleaded by the indefatigable John Ruskin. Later, it was argued in an urbane, chatty style by Charles Locke Eastlake in his famous book, *Hints on Household Taste* (1868). Eastlake espoused an aesthetic of 'rough workmanship' and praised the imperfections and tiny flaws which are conventional marks of handwork but usually absent in mechanized production ... The ideas of Ruskin, Eastlake and William Morris influenced the development of modern design, contributed to the vigorous revival of handicraft, and affected, at least indirectly, the folk art enthusiasts. Most of the articles categorized as folk art (even those industrially produced) manifest imperfections associated with hand production."

It is a touchstone of American folk art that the perfection is in the achieved whole, the coherence and density of integrated parts. However individually rough or faulty those parts, this is a valid sort of perfection, and workmanship of a quintessential refinement still to be honored.

Archness behind him, Ames solemnly calls out the big guns. "Thorsten Veblen offered an explanation of the preference from homemade goods." Yes, conspicuous consumption, beginning " ... pecuniary considerations are important in matters of taste; some people buy an object because of its great cost" and ending " ... no matter how it is accumulated, Veblen maintained, great wealth eventually draws admiration and prestige."

Then, "Robert Trent [author of *Hearts and Crowns*] utilized the concept of conspicuous consumption when he explained that to be fashionable an object had to display an investment of blood and treasure—a great outlay for expensive material or labor. [The strict parallel construction is expensive material *and* labor, but one half of the formula, without which it is not a formula and explains nothing, does not serve Ames's cause.] Folk art objects seldom reveal the investment of much treasure [you see], but there is abundant evidence of time consuming hand labor. When some of the objects are figured at today's wage scales for handwork, it is clear that if made now they would be costly, some of them prohibitively so. In this respect, the folk art world is like other parts of the art world; money is a crucial consideration."

I protest. Much of the needlecraft in American folk soft goods

was not of professional caliber, was not made to a wage scale and would have none now. Ames knows this; he has had his fling at our imperfections. But that's not what he is getting at. Apparently we are to lay aside the foregoing paragraphs on the craft moment, and Ruskin and Eastlake and Morris with their cult of rough workmanship, and take up as nearer the gist Veblen's idea of conspicuous consumption. But American folk art is not sought out and priced relative to man-hours involved but according to the surplus value of the art and/or period: a wage-scale for something not in demand is immaterial in a couple of senses of the term. It is not quite with us as with Veblen's climbers. We have no interest in blood and treasure.

So while it can't be disavowed that money (or the property value of unique objects) has become a consideration with folk art collectors as it has with other parts of the art world, Ames and Trent have managed wonderfully to confuse the charge—almost as wonderfully as Marxist critics, building on Walter Benjamin, have managed to simplify it.

4. A CONFLICT-FREE PAST:

a) "The fourth myth minimized social and economic conflicts and might be labeled the myth of a golden age, because the objects labeled folk art typically convey an image of a safe and serene life." The first eighteen words give promise, but the rest, beginning "because the objects labeled folk art typically convey ..." are irrelevant, at least outside the pale of bric-a-brac that typically comprise the folk art holdings at Winterthur. The arraignment should of course read "typically *are seen* as conveying ..."

b) "There is reality in these objects but it is not the reality perceived by many folk art rhetoricians. The reality is that many have had and continue to have difficulty coping with life and finding personal fulfillment. They have emotional needs which are not met and they use objects like small clay animals as vehicles of fantasy to escape to a world they can control and where they matter. The folk art writers would have us believe that the peace and calm that can be found in these objects is an accurate reflection of what life was like in the past. On the contrary, the past was a complicated, confusing, and unsettled as today. These objects provided light in darkness, serenity in chaos, and that may be why we still make and appreciate such objects." To begin with, we can discard the small-clay-animals-as-vehicles-of-fantasy-and-escape theme. Small clay animals of all styles and periods

perform such functions without notably affecting one's grasp of the world. Indeed, as Ames somewhat equivocally tacks on, they (or miniaturizations like them) are in a way designed to strengthen that grasp, spelling us at beleaguered moments that could otherwise break us.

(But what is to be said of an entire artistic heritage being debased to this modest office? That is, or ought to be, Ames's text. Not that its public goes to American folk art for an escapism which is in it, but that, in the absence of responsible critical guidelines, they go there at liberty to fantasize an escapism in it—"a world they can control and where they matter." Just so. Ames has done a service here.)

c) "There are social reasons for the perpetuation of the myth of a conflict-free past. Charles Keil [in *Urban Blues*] quotes a white master of ceremonies who explained to his audience 'these boys just love to play the music; that's all they do, day and night.' The implication is that these musicians are harmless and will not cause trouble; they will just play the old time songs. This is what some people want the folk to have been like too, so they define as folk art objects which seem harmless and free of conflict. In the construct called folk art they can find an earlier, simpler but mythological age devoid of class struggles and competition where social classes and races knew their places and were happy in them." Ames is clearing ground for a look at what has been a serious embarrassment to proponents of American folk art as our national emblem: its egregious use of the Black stereotype. I suspect this also to be a decided (if perhaps unwitting) check on the fortunes of the low art in high art circles. The reason is not hard to isolate. Art being one of the civilizing pursuits, and humaneness being one of the goals of Western civilization, or so it was once bandied around, an inhumane or prehumane Western art made during the last 175 years is a bewilderment both conceptually and emotionally. Such irregularities have been canonized in our era but with work only of the highest sophistication, indispensable to the formal tradition it modified.

It is good of Ames to limit his scorn to some people, yet the truth is that all of us beguiled by the art in American folk art have been forced into detente with its homely bigotries, in particular some striking, no, brilliant variations on that Black stereotype. The blend of elegant headwork with coarse feeling is oppressive—painful—so painful it is rarely talked of in explicit terms. What, after all, can be done about it? Observing this enforced tolerance, which he takes for choice, Ames goes on to read the problem a little backwards. Which is to say,

we (or some of us, for undeniably some of us do) don't *select* such images for their old-time mores and pronounce them American folk art, lulling our fearful souls with dreams of an age exempt from class struggles when races knew their places and were happy in them. We have the degraded things, and by any definition they are American folk art, a few of prime aesthetic interest, and it causes difficulties. We cannot have it both ways, equitably hating the wrong while admiring the beauty. It isn't possible with discordant values. One or the other must take precedence and in time prevail. We come to be connoisseurs or "sour mal-contents," as the essayist William Hazlitt described himself regarding a similar impasse in his "Letter to William Gifford, Esq." Loving poetry he nonetheless saw its vice—"the language of poetry naturally falls in with the language of power"[6]—and argued that either you admit the failing and move out between worlds, from where you will denounce even Shakespeare as he merits it, spoiling the beauty for yourself and others, or you move in with beauty (and structure or power) and spoil your humanity.

It is an ancient deadlock: beauty (and structure or power) versus humanity; and a seduction no less than embarrassment of our folk art is the guilelessness with which it lays bare the factors. These clods incredibly refined their heads by means of a most taxing and "civilizing" course of discipline, but they emerged scarcely nobler in their hearts, if one understands this to signify benevolence and charity and altruism. On the proof they ended as custom-bound and as illiberal as they began—yet they had learned to make art; they could distill and order their common thought into supremely "civilized" figurations.

Now, there is something dismaying in this will of art to structure experience but not to challenge the principles of it, to uncritically refine on the common norms and the common fantasies, the common fears and the commoner hopes, to be forever devising strange techniques to serve up bedrock assumptions. No. Ames's humanity is in the right place but his indignation is off. "Children who played with this figure [a dancing-toy]," he writes, "and even those who make such

[6]In Susan Sontag's essay, "Writing Itself: On Roland Barthes," there is a startling echo of this 150-year-old perception: "Language itself, which Barthes called a 'utopia' in the euphoric formulation that ends *Writing Degree Zero,* now comes under attack as another form of 'power,' and his very effort to convey his sensitivity to the ways in which language is 'power' gives rise to that instantly notorious hyperbole in his Collège de France lecture: the power of language is 'quite simply fascist'."

objects may not have fully understood the racism expressed in this stereotyped black man. But the laughter this evoked revealed a pervasive lack of sensitivity. The figure shares some of the characteristics of Zip Coon"

Perhaps he has read too much in the conventional literature. It is a canard of the art establishment that there is some ennobling or liberating virtue attached to the exercise of art. Western art is no necessary bringer of illumination, it is a bringer of art. Just as a man can laugh and laugh and be a villain, he can be common and common and be an artist, a very compelling artist, sometimes a great one. But of whatever rank or shade of opinion, he is not going to cut through the structuring norms or displace the patterns and unities by a hair, if he senses what's good for him—*qua* artist. Nor is it altogether as Auden said that he can't do it, but as much that he won't. "The language of poetry [and art] naturally falls in with the language of power." He may make a noise to heaven—as Goya did or Golub is doing—but he stands on common bedrock, beneath which the Promethean work begins, the deformalizing and disassembling. It is useful to have summarized a hoary old myth indeed.

5. NATIONAL UNIQUENESS:

"The rhetoric of American folk art confounds notions of freedom, democracy and personal expression ... John Gordon [a dealer] represents the most extreme positions: 'the American craftsman worked as a free man' unrestricted by the bonds of guilds or the demands of an aristocracy. He labored in an 'environment of no restraints' with the 'widest possible latitude of personal approach and innovation ... Here in the only democracy at work, a classless and free society granting gifts of opportunity, the miracles did happen. The flowering of free spirits produced a meaningful and abundant outpouring of expression that clearly revealed American life. The atmosphere nourished the spirit ... And is this wondrous output not the great democracy's distinct contribution to world art?'" Ames continues, "Gordon's 'wondrous output' buttresses the mythology of folk art and is too fatuous to merit an extended rebuttal. Perceptive writers have long seen the distortion in calling folk art the real American art and the true expression of the American people. James Flexner, John Kouwenhove, E.P. Richardson, and others have pointed out that much of what is called American folk art represents a transference to these shores of long established European traditions. In 'Pattern in the Material Folk

Culture of the Eastern United States,' [Henry] Glassie devotes considerable space to tracing the pre-American antecedents for many artifacts which became commonplace in American folk culture. But just as the myth of the melting pot supported the belief that when immigrants came to this country they threw off associations with their native lands and retooled [themselves] as that new product known as the American, the myth of nationalism maintains that American material culture at an early date became distinct from and superior to that produced in the rest of the world ... It leads writers to attempt to discover the American component of American art without first asking whether anything is American ..."

I share with Ames a distaste for senatorial eloquence. Gordon is an enthusiast, not a writer. It is one of the many misfortunes of American folk art that so few competent writers have been involved with its definition. Nevertheless, while deploring the tone, I can't in conscience shrug off the claim—that wondrous output—said to be too fatuous for extended rebuttal. I blush and cringe under Ames's sneer but can't bring myself to laugh along. It is as evident to me as it is to Gordon: the miracles did happen.

There is a game words sometimes play with eloquence when honest feeling is driving it. They betray the narrow objective. Assertion tends to equivocate, to rise above faction to some more general view, containing the germs of its antithesis, and with a little help can be made to serve a number of speculations. Thus, as Gordon says, there was a flowering of free spirits which clearly revealed American life; yet not in the halcyon light he means us to understand. Liberated clod spirits do not normally flower if they can help themselves, they go to leaf. They put out the orthodox regional wares with boundless new energy and confidence. But an environment of no restraints, with the widest possible latitude of personal approach and innovation, could not have seemed a blessing to people faced with providing their own. Gordon has merely to fancy himself under such a pressure of latitude and innovation, without skills or concepts, yet with all one's importance in one's hands—literally—to make out how excruciating it must have been to come to flower as some of them did.

Gifts of opportunity? Yes, yes, but to do what? What they couldn't do, had no disposition to attempt to do, would as soon have had done for them as always in the past? Meditating, organizing their heads, struggling with abstruse problems of configuration, not as an ornament to their lives but as that kind of existential weight which is

a condition of their lives? It was a gift thoughtlessly tendered. And yes, the atmosphere, the "great democracy," did nourish the spirit—by leaving it to whatever awkward importance it could make for itself, out of itself, in despite of the atmosphere. Good nourishment for a few but not, I expect, what either Gordon or the great democracy had in mind.

What then is American about our folk art? Its ambition and *weight:* that compulsive self-investment, edge to edge, of the smallest embroideries and carvings; the dense formal saturation of quilts and rugs until they can almost not be seen (even by eyes ready to see them). No other society encouraged this in the rank-and-file and no other society brought it on. That is what it is, and European traditions and pre-American antecedents are as discontinuous with such a cultural jump as apes with homo sapiens.

Ames says, "The myth of nationalism maintains that American material culture at an early date became distinct from and superior to that produced in the rest of the world." In fact, it became not superior material culture but an enterprise that was not material culture (or Americana) at all. It became a new strain of discourse, unlocateable within the academic systems, neither folk nor primitive nor artisan nor "popular," but in the most accurate sense of the term —and I am aware of no other occurrence of it—an outsider art, made by insiders. Ames and his friends will scarcely credit the notion: weight and saturation, let alone the self-investment (apart from man-hours) in a little sculpture of a horse, are not datums. They will carry on with their absorbed contextualizing, grouping motif with motif and schema with schema, hunting down where they can an old world original, while around them brood a sprinkling of artifactual records of the most alarming presence, charged with the real remote magnetism, that only novelty, never to be faked or mistaken, and ready to put them back on the job market if but once they forget their datums, turn suddenly and look.